Peoria, Illinois Revisited

IN VINTAGE POSTCARDS

12/2012

To Duncan

LaDonna Bobbitt

Charles Bobbitt

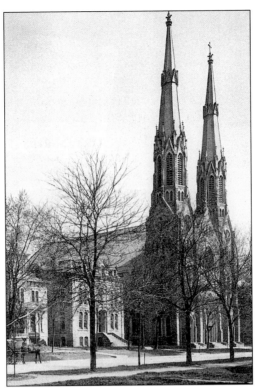

St. Marys Catholic Cathedral, located at Madison and Green Streets, is the most magnificent of churches before 1900. It is constructed of Anamosa white stone, and there are two 230-foot spires. Gothic architecture supported by a steel frame graces the entire building. Noted New York City architect Ralph Adams Cram designed the church, which was completed and dedicated May 15, 1889. The church still serves Peoria's Catholic community.

POSTCARD HISTORY SERIES

Peoria, Illinois Revisited

IN VINTAGE POSTCARDS

Charles A. and La Donna Bobbitt

ARCADIA
PUBLISHING

Published by Arcadia Publishing
Charleston, South Carolina

Printed in the United States of America

Library of Congress Catalog Card Number: 00-102032

For all general information contact Arcadia Publishing at:
Telephone 843-853-2070
Fax 843-853-0044
E-mail sales@arcadiapublishing.com
For customer service and orders:
Toll-Free 1-888-313-2665

Visit us on the Internet at www.arcadiapublishing.com

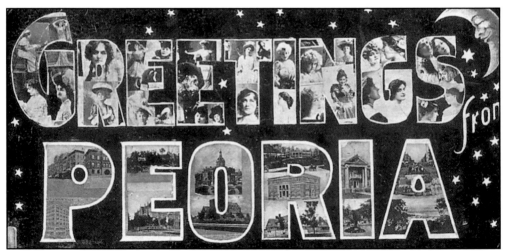

"Greetings from Peoria" were commonly used in 1907. This card, due to Federal law enacted in 1907, could not carry a written message. Note that the name Peoria is spelled out by using a series of reduced-size postcard scenes of Peoria landmarks. The maker of this card managed to capture 14 different views. Among the most recognizable were the Peoria County Courthouse, Bradley University, Creve Coeur Club, and Schipper & Block.

CONTENTS

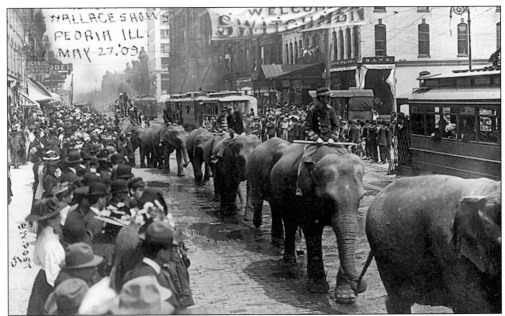

Crowds lined both sides of Southwest Adams Street on May 27, 1909, to welcome the Hagenbeck Wallace Circus. They entered Peoria by marching the elephants down Adams Street in single file—tail to trunk. The banner on the postcard reads, "Welcome Switchmen." Note the trolley still using iron rail tracks on the brick streets in this downtown scene.

Acknowledgments

Throughout the process of writing this book, the authors found their journeys to the Peoria Public Library to be necessary. The staff was always so pleasant and helpful. There is only one other place in the city of Peoria where information may be obtained on so many obscure subjects, and that is the special collections at Bradley University. Both of these institutions have staff members that were always able to locate that extra bit of information that was imperative to the completion of this book.

Special thanks must go to Tom Kallister; Dave Peters; Karen Deller; Mary Ruth Ginn; Bob Bushell; June Grayeb; Bob Harmon; Alma Brown; our physician, Dr. Gregory Clementz; and our dentist, Dr. Gregory Wahl. Each of these individuals played an important role in making the authors aware of how important a second book of Peoria Postcards would be.

We would also like to thank the very talented Monica V. Wheeler, who made our search for material much simpler by allowing us to utilize her extensive collection of outstanding books on Peoria history. Bill Adams helped us to fill the gaps in this book through the use of his newspaper column—we appreciate his talent. Thanks to Pat Kenny for her permission to use the article on Deltiology as it appeared in the *West Bluff Word*. Debra Gust at the Lake County Museum graciously educated the authors on the Curt Teich Postcard Archives, and we greatly appreciated her permission to allow us to use the postcards for this book. It would have been next to impossible to produce this book omitting the Curt Teich Postcards. The authors hope that one day their children—Karen, Phil, and Angela—will learn to love and appreciate Peoria history as much as their parents have. Lastly, we would like to thank Ernie Grassel. Ernie always managed to find time for the authors, and his guidance and suggestions were greatly appreciated.

INTRODUCTION

Deltiology is the science of postcard collecting. Deltiology initially began in Europe in the middle of the nineteenth century. The first postcards were typographic in design and appeared in Austria in 1869. Postcards then made their appearance in France in 1870, about the time of the Franco-Prussian War. These cards were illustrated with soldiers, muskets, and military paraphernalia publicizing the war effort. The modern picture postcard made its debut at the Chicago Exposition of 1893. From that point on, postcard collecting became a mania. In 1906, 700 million cards were sold in America alone, and only seven years later, over 968 million were sold.

Societies of collectors have been organized in many major cities. Exhibits and auctions are advertised regularly, and thousands of people have discovered the joys of Deltiology. The postcard collector may even own something of great value—cards that were sold for 1¢ in 1909 can cost as much as $100 today!

Peoria picture postcards carry three basic messages when they are used: a communication to another person, a specific point in time captured in a picture, and a history of a place. All three of these messages are reiterated through the years with each use of the postcard. The authors strongly suggest the use of a magnifying glass to bring the small prints to life. By doing this, details are discovered that were previously hidden.

All of the images used in this book were from the personal collection of the authors. This collection now contains more than 1,500 cards and is continuously growing. Frequently, the authors ask themselves if they have enough, and the answer is always the same—never!

One

BEFORE 1900
EARLIER PERIODS AND DEVELOPMENT OF PEORIA

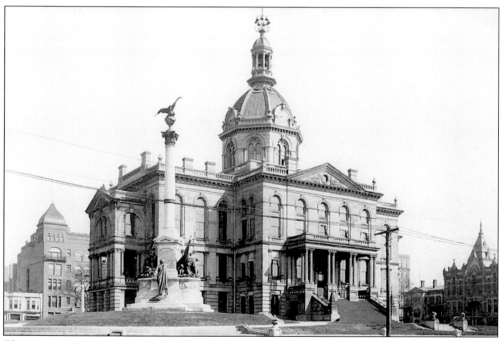

The second Peoria County Courthouse, completed in 1835, was obsolete by 1870. Rapid population and county business growth increased the need for more space. Therefore, the county supervisor proposed the issuing of bonds for the new courthouse, as pictured above in 1874. The cornerstone was laid on September 30, 1876, for this grand Venetian-style building, and it was constructed with a foundation made of Joliet stone. The exterior walls were done in Ohio sandstone and the paving stones of the porticos came from Lemont, Illinois. With the exception of an addition in 1927, this building remained fairly unchanged until the time of its destruction in 1963 to make way for the present courthouse.

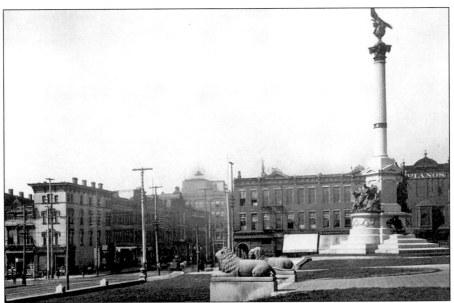

The Soldiers' and Sailors' Monument was dedicated in 1899 by President William McKinley. Sculptor Frederick Ernst Triebel received the commission to produce this monument in Pistojo, Italy. One of the largest parades to occur in the Midwest was for this dedication event. The parade consisted of over six thousand children, uniformed soldiers, and eighteen carriages filled with prominent citizens. Following the event, the president and members of his cabinet dined with Mr. and Mrs. J.B. Greenhut in their home at Sheridan and High Streets.

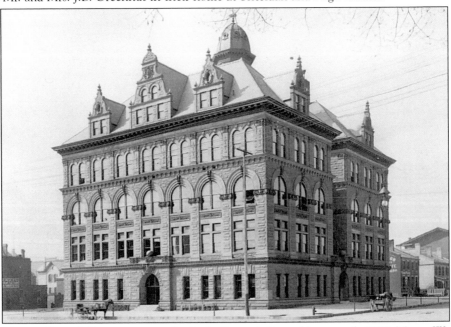

Peoria's new Flemish Renaissance–style city hall was dedicated January 5, 1899. Mayor Warner and the city council were present to welcome visitors that day. This four-story building was constructed at the cost of $271,500, with John R. Whalen as superintendent of construction. Portage, Wisconsin, was the origin of the exterior sandstone. The Peoria architectural firm of Reeves and Baillie designed the building, which still serves the city after one hundred years.

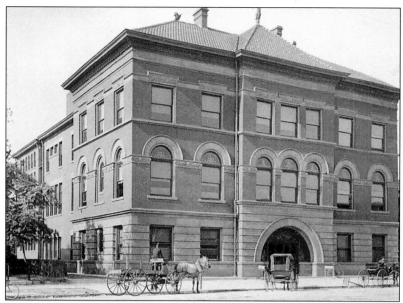

The second building to house the Peoria Public Library, pictured above, was approved by the city council at a cost of $67,850. However, this cost was covered by the $75,000 sale of their previous building located at Main and Jefferson. Upon completion of this project, the building opened in January 1897. Annexations to and expanded growth of the city of Peoria created a need for still another library building. This building was demolished in May and June 1966, and the new library opened in 1968.

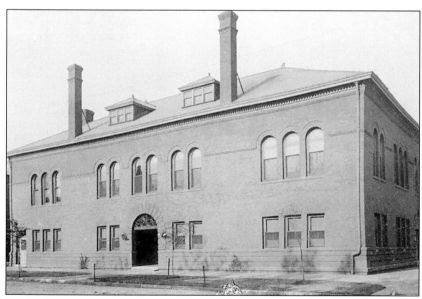

The above building was erected in 1893 for the Peoria Women's Club at the cost of $45,000. The First Baptist Church had abandoned this site upon completion of their new church at Hamilton Boulevard and Glen Oak Avenue. The club was chartered in 1891, and began plans for their new home shortly thereafter. This building instantly became the cultural center of Peoria. Mrs. Clara P. Bourland was the club's first president. The structure still stands with its exterior basically unchanged since the day it opened in January 1893.

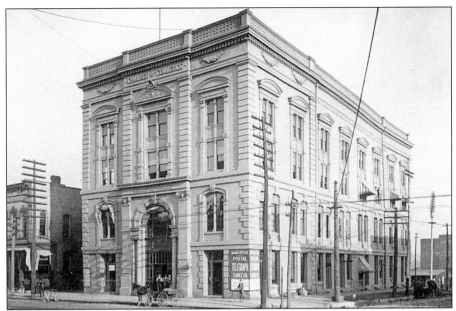

The chamber of commerce and the board of trade both occupied this structure located at the intersection of Harrison and Washington Streets. The board of trade was chartered in 1869 and fostered the trade in grain—mainly corn. In 1875, the above building was erected, providing commodious quarters. It was rare in this time period for cities the size of Peoria to acquire such a faculty. The dominant forces at that time were the distillers and cattle feeders. A fire before 1889 caused heavy damage to the exterior of the building, which required some remodeling, including the removal of the middle tower on the third floor. The building was destroyed in 1967 for the construction of a modern board of trade building, which still stands today, but is no longer occupied by the board of trade.

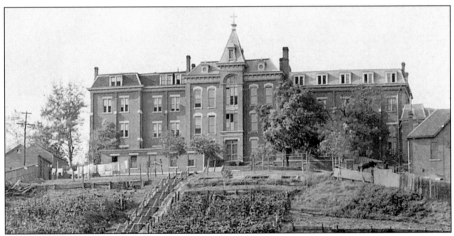

Bishop John L. Spalding purchased the Isaac Underhill home at 248 Bluff Street (now Glen Oak) for the St. Francis Hospital in 1877. He paid $10,000 for this 1841 mansion. Mrs. Lydia Bradley was the previous owner of this property. The postcard above demonstrates that the institution remained true to the character of the original house as additions were made. The center was the original structure, the left wing was completed in 1885, and the right wing was added in 1890. The original portion of the old Underhill dwelling was removed in 1945.

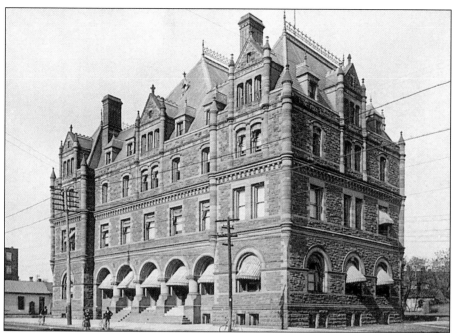

The United States Postal Service purchased the Puterbaugh Building at Main and Monroe in 1885, removed that structure, and constructed the one pictured above in 1889. This building served as the post office, federal courts, and other agencies until 1937. The United States Government allocated over $1 million in 1937 to remove and construct the present building. Additional lots were secured, and the structure, as it appears today, was dedicated and opened on September 10, 1938.

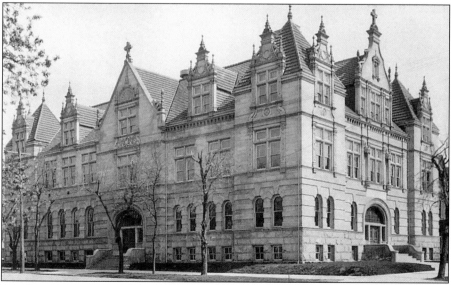

Spalding Institute was named for Bishop James L. Spalding's brother, Reverend Ben Spalding, and its doors were opened in 1899. Reeves and Baillie designed this building, which reflected German Manor House lines. The main entrance was favored with two limestone figurines. The first class graduated in 1901, within two years of the opening. Fortunately for Peoria, the building's exterior remains much the same as in 1899.

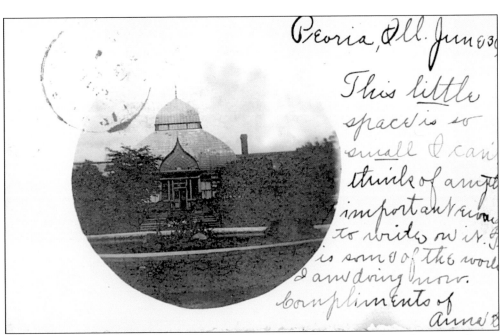

The handwritten text on the card reads:

Peoria, Ill. Jun 03

This little
space is so
small I can
think of anything
important enough
to write on it. It
is some of the work
I am doing now.
Compliments of
Anna

The Palm House Conservatory is presented here in a card that was either of poor quality, or done by an amateur photographer and mailed in 1899. The space provided by the smaller oval picture permitted the writer to exchange a message with the receiver. Congress did not permit such messages, other than the name and address of the receiver, prior to 1907.

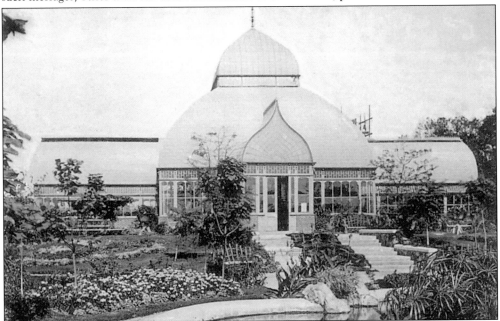

The Palm House Conservatory in Glen Oak Park was completed shortly before the above picture was taken in 1897. For many years the building was a central attraction of the park, and tropical plants were an important item on the agendas of every visitor for nearly 57 years. Rising costs and the growing needs for a park made this building obsolete. The entire structure was demolished in 1950, and the site was then used by the Glen Oak Zoo.

14

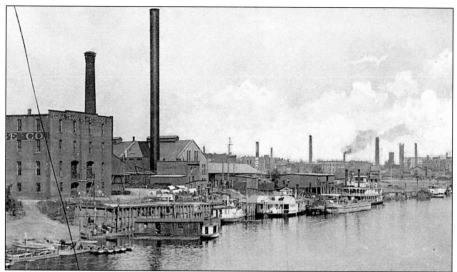

The Peoria Riverfront has been graced with the presence of steamboats since 1829. The number increased steadily until about 1860, when there were more than 75 boats making daily trips to Peoria. This riverfront traffic was still strong in 1896, as this postcard displays. Besides utility boats, the tourist trade also remained on the river well into the 1940s. Notice that the buildings are located very near to the water's edge. Peoria Transfer and Storage is located on the far left.

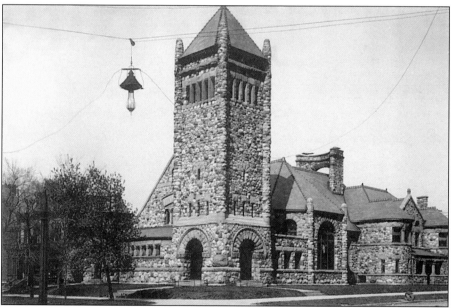

The Second Presbyterian Church at the corner of Madison and Jackson (now Spalding Street) was dedicated in 1889. The structure is most unique in design, and it contributes greatly to the architectural beauty of the city. It is composed of split granite boulders, with trimmings of buff Bedford stone, and a roughhewn and slate roof with copper turrets. The theme of the entrance continues into the interior. The congregation amalgamated with the First Congregational Church to form the First Federated Church in 1937. No longer a church, the building had since been used by several different businesses.

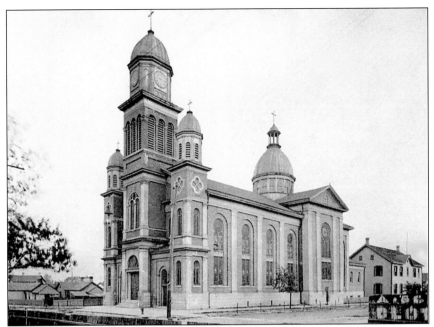

Bishop Spalding dedicated St. Boniface Church, which was later called St. Ann's Catholic Church, in 1895. The Peoria architectural firm of Richardson and Salter designed the edifice of the Romanesque Revival–style building. After some changes, such as name and interior, the building still stands at the corner of Antoinette and Louisa.

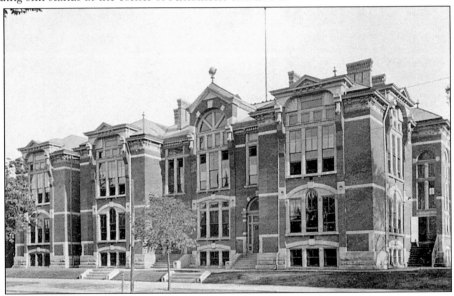

Central High School was located at North Monroe and Fayette as is appears above in 1885. V. Jobst and Sons erected the building at the cost of $28,921, and an addition was completed in 1895 at the cost of $8,769. The finished building consisted of ten large classrooms, a library, laboratory, and an assembly room with seating capacity for 400 students. The facility served the community for just 31 years, and in 1916 a new building was constructed at North and Richmond Streets. The previous building was used for the school administration, and was finally removed in 1960 to make way for Interstate 74.

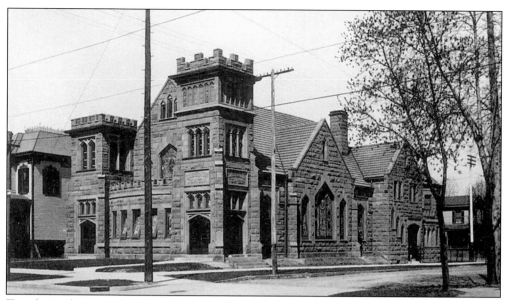

Temple Anshai Emeth as pictured above was dedicated in 1898 by Isaac M. Wise, founder of Reform Judaism in the United States. This congregation had lost their previous temple just two years before in a fire at Jefferson and Liberty Streets. The edifice of this building was sandstone —similar to City Hall. Notice the two Norman-style towers on the building. The congregation relocated to 5614 University Street in the 1960s. The Christian Assembly Church occupies the building today.

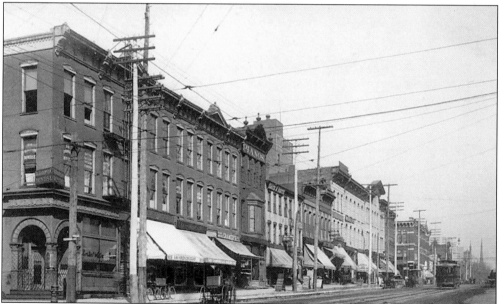

The three hundred block of Main is pictured here as it appeared in 1897. The Rouse Building, which housed the Central National Bank beginning in 1893, is located to the far left. The Zimmermann Drug Store name appears on the awning hanging to the left of the bank. The Crescent Theater, and later the Apollo, was in the center of this block by 1914. In the far right corner you can see the former library building, which was later used for other purposes and subsequently demolished to accommodate the construction of the Lehmann Building.

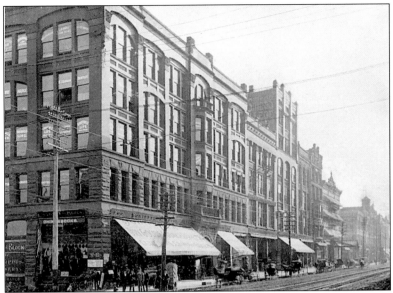

The Woolner Building and all adjoining buildings, pictured here in 1899, were removed in the late 1990s to accommodate the new Technology Center. This building dates back to about 1890. The site next to the Woolner Building became the First National Bank in 1911. The next storefront was the Wheelock Building, which housed the Wheelock Company, who dealt in china, glass, and lamps. Two top floors were removed from the building in 1935 to accommodate the next occupant—J.C. Penney Company. The building at the corner was the Fey Hotel, which was razed in 1934 to make room for the Montgomery Ward store. Located at the next corner was the Prochazka Hotel, which was built in 1898.

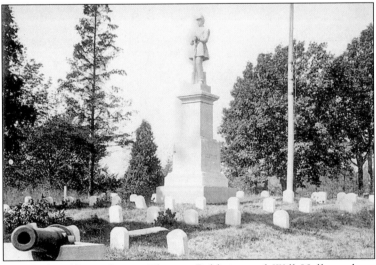

Henry Lightner, Judge Alonzo Peters, Thomas Baldwin, and Will Hall purchased 200 acres together and subsequently established Springdale Cemetery in 1855. Additional land was later acquired, bringing the span of the cemetery to 255 acres. With visions of Peoria's future, these men formed the Springdale Cemetery Association. Mary Miskaman was the first person buried here in 1855. Of special interest are the four cannons that were installed in 1874—these have since been sold after 125 years. The Soldiers' Monument is pictured above in 1899 guarding the Civil War dead.

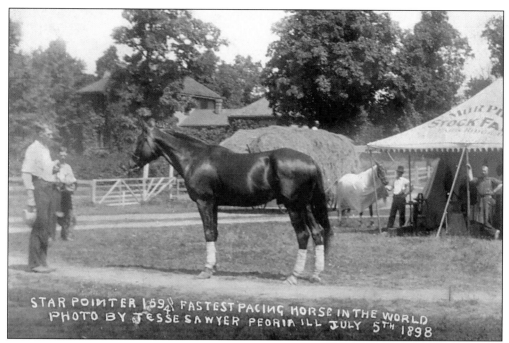

STAR POINTER 1:59¼ FASTEST PACING HORSE IN THE WORLD
PHOTO BY JESSE SAWYER PEORIA ILL JULY 5TH 1898

Star Pointer was invited to Peoria during the racing season in 1898. Pictured along with the horse is the tent displaying the sponsor, Murphy's Stock Farm of Park Ridge, Illinois. The track at Peoria also drew the Grand Circuit for many years. At that time, Peoria was one of the fastest tracks in the nation. Star Pointer beat the Peoria track record of 2:05 with a time of 2:02.25. This track was located on War Memorial Drive, and currently serves as a sports stadium for the Peoria Board of Education.

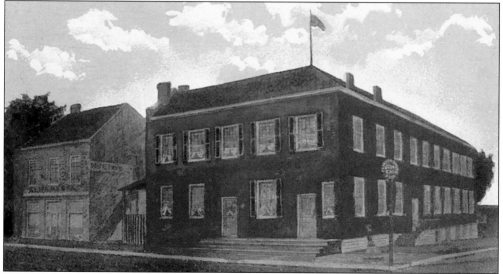

The Clinton House was built in 1837 by John R. Caldwell and was described as a very nice two-story brick hotel at Adams and Fulton Streets. John King leased the hotel from Caldwell and established an excellent business reputation. Beginning in 1846 there were a number of owners, including the father of a future mayor, John Warner. The building was destroyed by a fire in 1853.

Pictured above is the one hundred block of Northwest Jefferson as it appeared in 1895. The first building on the far left was John Hamlin's home, with an added front commercial facade. The large building in the left center of the card was completed as the YMCA in 1891, and was subsequently sold to the German Fire Insurance Company. Both of these buildings were destroyed in the 1916 fire. Next to the Fire Insurance Company building was the Grimes two-story brick structure, which housed the family-owned water company. This building was razed to make way for a bus station, which was then replaced by the current structure—the Savings Tower Building. The National Hotel stood to the far right and was destroyed by fire in 1911.

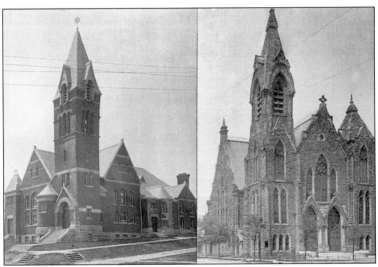

This double postcard shows the First Presbyterian Church and the First Congregational Church as each appeared in 1894. The First Presbyterian Church (on the left) was completed in 1889 on Hamilton Boulevard. There has been little change to the exterior of this structure, which is still serving its community 110 years later. The right side of the postcard shows the First Congregational Church, which stood at Monroe and Hamilton from 1875 until it burned in 1936. The congregation then merged with the Second Presbyterian Church in 1937 and relocated on Sheridan.

This double card of St. Paul's Episcopal Church (top) and the First Baptist Church (bottom) was produced in 1898. St. Paul's was built in 1890 at Monroe and Main Streets. This building was torn down in 1959. The congregation built and opened their new building on War Memorial Drive in 1956. The First Baptist congregation erected the building shown here in 1892 at Hamilton and Glen Oak Streets. The church relocated to Lake Street in 1957, and the building pictured here was razed in 1959.

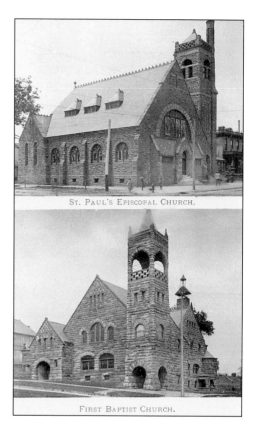

ST. PAUL'S EPISCOPAL CHURCH.

FIRST BAPTIST CHURCH.

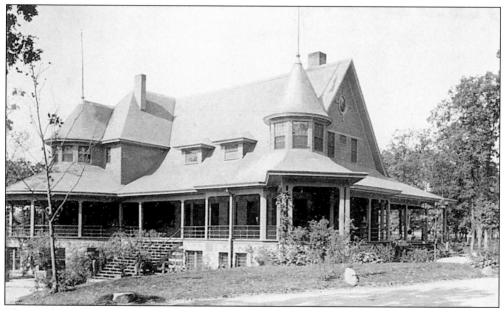

The Pavilion at Glen Oak Park was the administration building for the Peoria Park District. This verandah-sweep structure was completed in August 1896. The interior has been updated many times, but the exterior remains the same. The architects were Reeves and Baillie of Peoria.

The Glen Retreat at Glen Oak Park offered visitors a way to retrieve sulfur water, as pictured above. Water flows have changed through the years and rendered this pool useless.

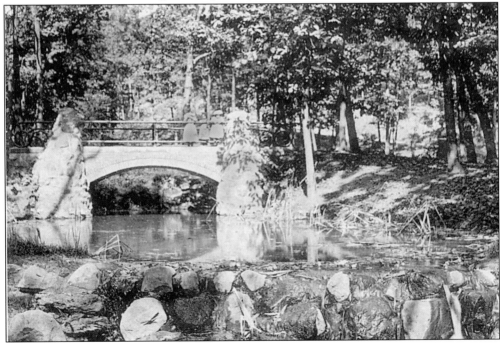

The bridge and pond in Glen Oak Park was a favorite place to be photographed in 1898, as this picture reveals. The bridge was constructed of brick and stone that guaranteed to provide a picturesque spot in Glen Oak Park for many years to come.

Two

1901–1920

PEORIA: CAPTAIN OF THE CENTURY

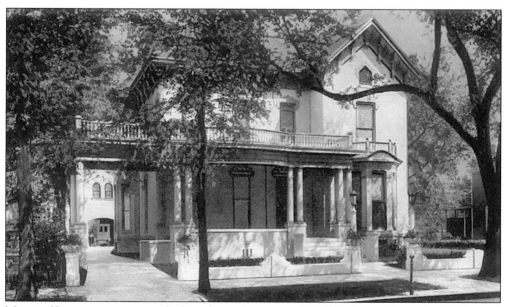

Martin Kingman constructed the above house at 203 Northeast Perry in 1879, and Harry E. Cumerford acquired and converted it into the Cumerford Funeral Home in 1912. This building had replaced the John D. McClure home, which was constructed earlier but was damaged by a tornado. By 1925, Tom W. Endsley became a partner, and the company became the Cumerford-Endsley Memorial Home. Glenn Beleke became associated with the firm in 1939. In the 1970s, this company moved to the Milton Pierson home, which had been previously converted to a funeral home. This firm became known as the Cumerford-Endsley-Digle Funeral Home, and is located at 428 West McClure.

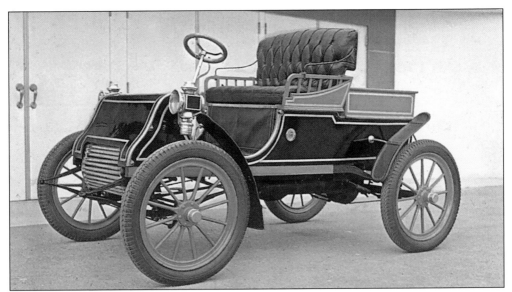

The Glide automobile pictured above was manufactured at the Peoria Heights plant in 1904. The engine was a single cylinder 8-BP horizontal in the center of the body, and planetary transmission with chain drive. The John B. Bartholomew Company founded and produced Glides from 1902 until 1920 at the Peoria Heights plant. This physical plant was absorbed by the Premier Malt Products Company in 1933, and later merged with Pabst Brewing. Following the closing of Pabst in the 1980s, the original building was torn down, leaving only the office complex intact.

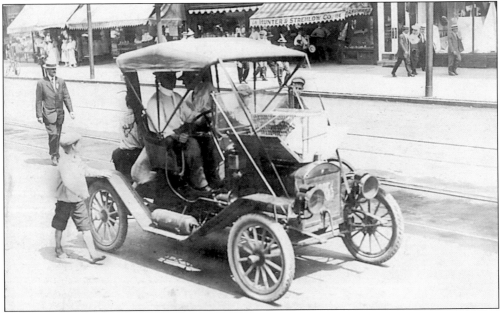

This photo of the one hundred block of Southwest Adams demonstrates the slow onset of the age of the automobile as citizens of Peoria cross the street leisurely. The retail businesses of Welte, Wieting, Hunter, and Strenlow Company and other small businesses dominated this block until the introduction of the S.S. Kresge Company in 1916. The driver of this canvas-covered auto remains unidentified.

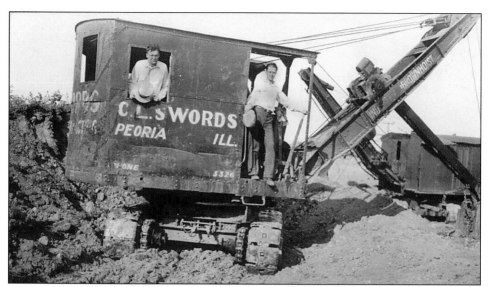

Charles L. Swords used the above postcard to advertise his contracting business. Swords was the sheriff of Peoria County from 1942 to 1946. The Swords family purchased the Hotel Pere Marquette in the 1940s. During his contracting years, Swords developed El Vista and Fernwood additions into residential areas. Swords Hall on the Bradley University campus was named for both Charles and his son Earl. Charles Swords died in May 1969.

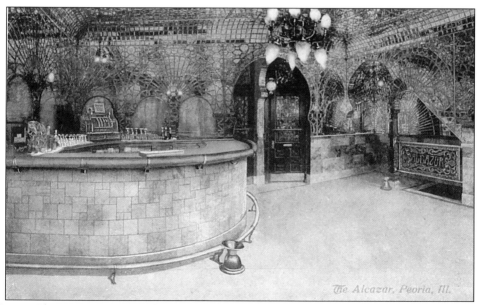

Niagara Place was once a small street that ran for one block between Jefferson Avenue and Adams Street. Presently, a parking deck covers most of this area, except for a one-block alley. This same area had been home to various saloons before Prohibition. The most famous of these saloons was the Alcazar, which was located behind the Woolworth Building on Adams. The facade was rather exotic, and the interior was of a Moorish design with woodwork of hand-carved South American Vermilion. The official name was the Alcazar Buffet and English Chop House, and it was opened by W.A. Schmitt. This business closed with the advent of Prohibition and was torn down to allow for the telephone company's expansion in the 1920s.

Lilly Aldridge, pictured to the left, was photographed by Nance's Studio of 415 South Adams. She is shown in her home in this 1912 postcard. By 1910, printing home photos onto postcard stock provided people with a photographic history that is still cherished today.

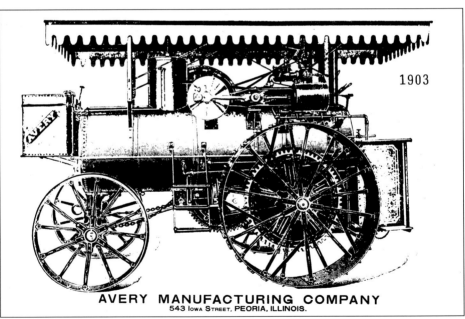

1903

AVERY MANUFACTURING COMPANY
543 Iowa Street, PEORIA, ILLINOIS.

A Civil War veteran, R.H. Avery returned from the war with a refreshing idea to manufacture agricultural implements in the Galesburg area. In 1882, he moved to the Peoria riverfront, north of the downtown area. With the establishment of the Avery Company, a new suburb of Peoria was born and became known as Averyville. Many steam tractors were produced by this company, including the 1903 model shown above. Many buildings of the industrial complex still remain.

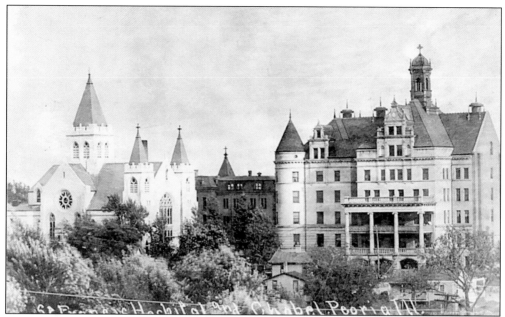

The St. Francis Hospital complex is pictured as it appeared in 1915. The left side of the postcard is the English Gothic chapel that was completed in 1909. The six-story building to the right was completed in 1900 to serve the increasing demands on the hospital.

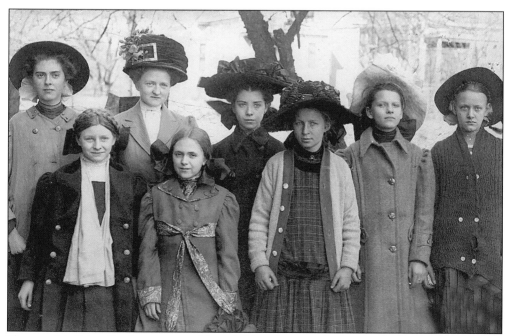

Florence M. Sykes (back row, second from left) is photographed with what may have been her family, in 1910. Postcard stock was used to capture this important moment in the lives of those present. Florence Sykes's residence was at 111 East Arcadia Avenue, and she was a clerk at the Avery Company.

The Sandmeyer home, located at Northeast Adams and Evans, was a fine example of a smaller home that was built with many of the amenities found in larger homes contracted in the 1890s. Notice the iron fence and the gate with the cement posts. The house was eventually destroyed and is a business location today.

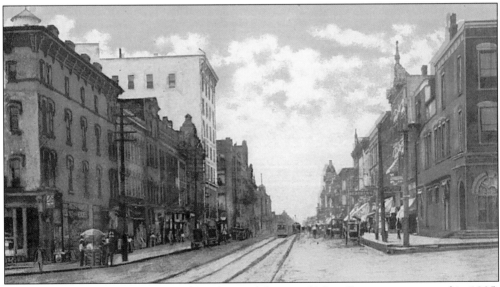

Pictured above is the intersection of Southwest Adams and Main Street as it appeared in 1905. The McDougal Pharmacy, to the far left, was demolished in 1922 for the expansion of Clark Department Store next door. Of particular interest was Bergner's, on the right side of the street, and to the left, towering above many buildings, was Schipper and Block (now Bank One) at Fulton Street.

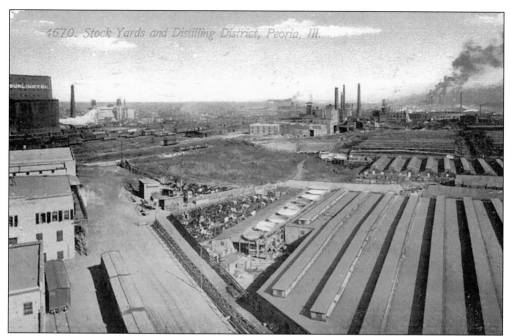

Pictured here are the stockyards and distilling districts of Peoria as they appeared in 1914. At that time there were four major packing houses in the city—Wilson's, Godel & Son, C.F. Hill, and McElwee. All were located less than a mile apart. The beef and pork-related industries flourished as early as 1837, and they still process in Peoria today.

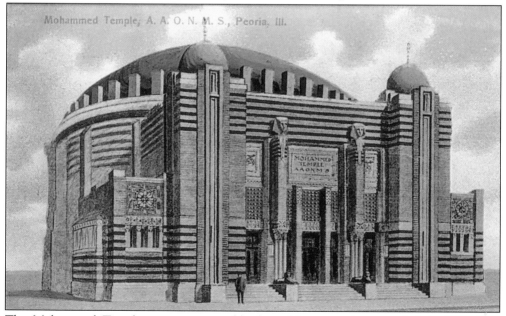

The Mohammed Temple was one year old when this postcard was mailed in 1910. The well-known Peoria architectural firm of Hewitt and Emerson was selected to build this striking Near-East-patterned building located at 207 Northeast Monroe. This postcard was produced from architectural drawings. The mosque was destroyed by fire in 1936, and a new mosque was constructed using the former building foundation front by 1938.

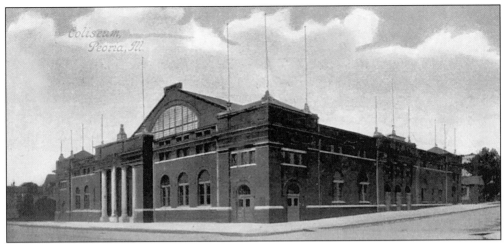

The Coliseum was located at the intersection of Northeast Adams and Hancock—currently the site of the National Guard Armory. This municipal building was constructed at the cost of $50,000 and had a seating capacity of 7,000. The completion date was 1901, and the Chicago Symphony Orchestra performed the first concert to a full house on May 6th. The Peoria Railway Company, for consideration of the renewal of its franchise, provided $57,000 to construct this building on a city-owned lot and, upon completion, turned the title over to the city. The building was eventually destroyed by fire in May 1920.

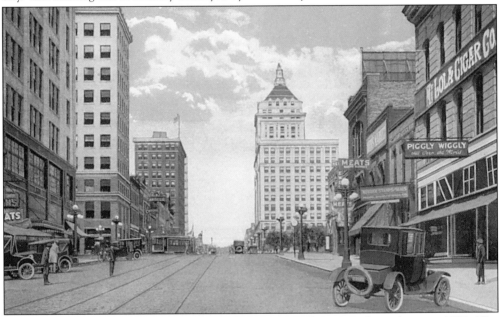

This is a view of the two hundred block of Main Street facing north in the year 1925. The view captures many of Peoria's tallest buildings. The Piggly Wiggly store had recently been introduced to Peoria as a self-service grocery store. The Clark Department Store dominates the left side of this card. The first addition of the Central National Bank was completed across the street from Clark's. At the far end and slightly to the left is the Lehman Building, which was completed in 1914. The Commerce Bank Building was completed in 1920. All of the buildings on the lower right side were demolished in the 1960s to make space to construct the Caterpillar World Headquarters.

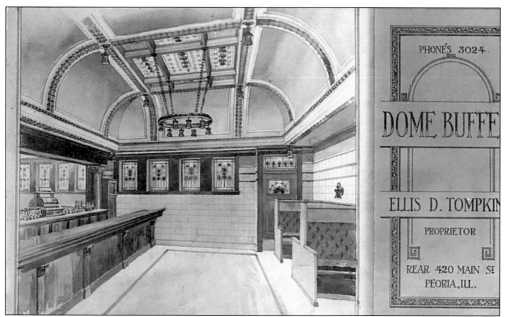

The Dome Buffet and the bar shown here were products of the flourishing small saloons in downtown Peoria in the late 1890s. This establishment was located in the far corner of the Lekas' Restaurant at 422 Main Street, but was a separate business that catered to cast members of the Orpheum Theater just across the small alley. After Prohibition, this business closed and the exterior door was sealed. The ceilings were lowered, and this once grandiose business became a private meeting room for Lekas' Restaurant.

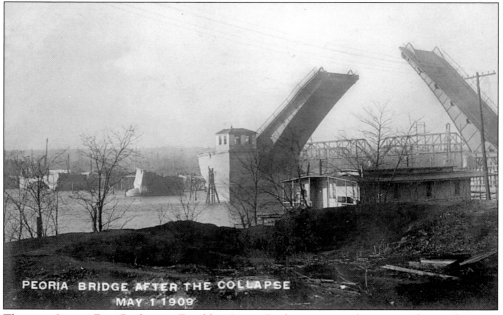

The new Lower Free Bridge, or Franklin Street Bridge as it was later named, was the most photographed disaster in Peoria history. After the collapse in 1909, the Tazewell side was reconstructed and angled to the left from Peoria, and the entire structure was completely removed in the mid-1990s.

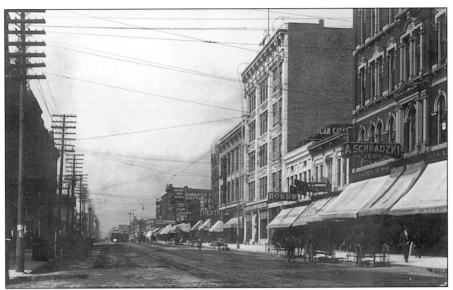

The three hundred block of Southwest Adams is shown here as it appeared in 1909. The canvas-covered buggies still dominated the street scene. The 5¢ theater to the right was the Liberty—an early "Nickelodeon." Rex Studios later occupied the space. The Bennett Building, near the middle of the photo, was home to the Commercial National Building until their new building was constructed in 1926. Sears occupied the Bennett Building's first floor at 321 Southwest Adams beginning in March 1928. Extensive growth soon required this company to occupy the entire building. Washington Square's completion in 1965 brought Sears to the riverfront. All the buildings on the left side of the photo have since been removed. To the right is the Hartman's Furniture Store, which became Cohen's in 1925 and still stands today.

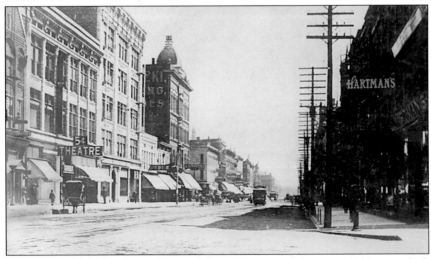

The three hundred block of Southwest Adams is pictured here in 1910, just before the automobile age. At the far end of the photo, a view of a streetcar was captured. Streetcars were introduced to Peoria in 1870, when they were pulled by horses. Later, electricity powered the streetcars, and by the late 1940s gasoline became their main source of power. Towering to a height of four stories was the former Masonic Temple building, which was built in 1875. The Masonic Lodge sold the building to Schrodzki's, which remained at this location until the building was sold to Commercial Bank in the early 1920s and removed in 1925.

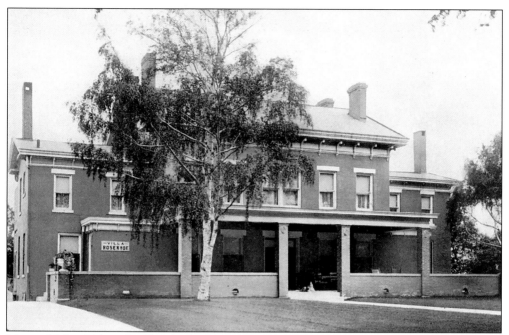

Mr. and Mrs. Tobias Bradley built this home at 708 West Moss Avenue in 1843. Tobias Bradley died in 1867, and Lydia Moss Bradley assumed all of her husband's business ventures, building quite a fortune by the time of her death. The next occupant of this great home was J.P. Schnelbacher, a very successful local shoe merchant. It was at this time that the name Villa Rosenhof was attached to the house. A later renovation altered the front porch into a Greek Revival style. The home later was converted into apartments and is presently owned by Bradley University.

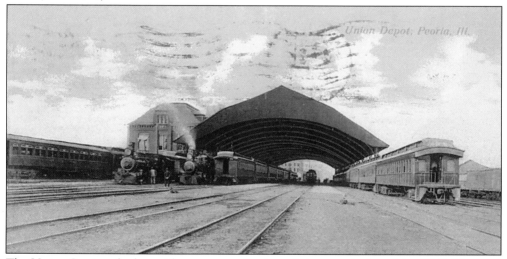

The Union Station shed provides a panoramic view of the complexity of the PP & U system in Peoria as of 1901. To the far left is the southern end of the huge Union Station, which was constructed in 1882 at State and Commercial Streets. Fire was not the cause for the demise of the shed, but rather an accident that occurred in October 1927. A flat car hit the side of the shed's wood structure, causing irreparable damage. However, fire did destroy the main terminal building in 1963.

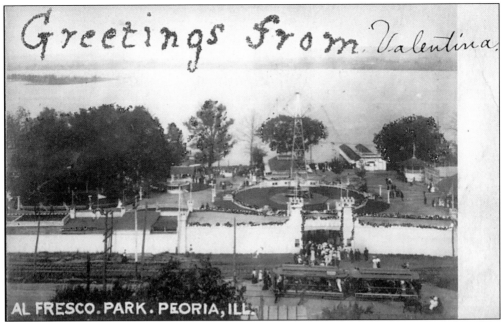

Al Fresco Park, Spanish for "open air," was an amusement resort that opened in 1906 on the shore of the Illinois River on Galena Road. The main attractions were a roller coaster, numerous carnival spectacles, dining, and bathing. A two-story pavilion and beer garden overlooking the river provided refreshments. During WW I, the park closed and fell into disrepair. By 1929, the bathing beach was reopened by Fred D. Feyler for another 15 years. The streetcar line was extended to the gates of the park for easy public access. Nothing remains today of the popular park and beach.

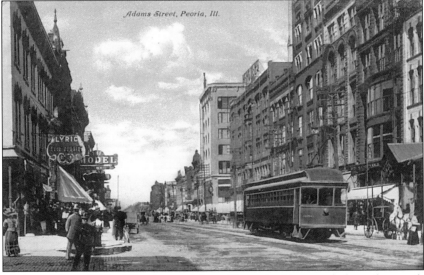

This is an image from 1915 of Southwest Adams Street looking north from the two hundred block. The age of the automobile was fast approaching. The Woolner Building to the right was still functioning as an office building, and Schipper & Block was located across the street. A small edge of the Fey Hotel may be seen to the extreme right. By the late 1990s, all buildings to the far right had been removed.

34

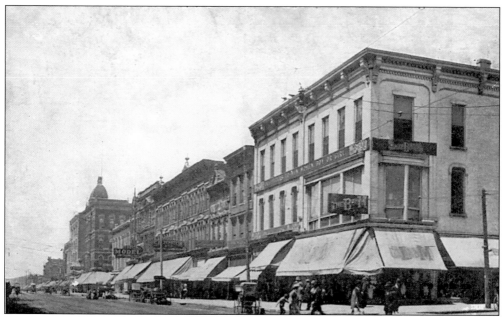

The B & M Store (Jacques Bloom and Max Mayer, owners) dominates this very early view of the intersection of Southwest Adams and Liberty Streets. The store opened in May of 1890. Take note of the initials on the fabric awnings. The store remained open until 1953, when the building was torn down. It was replaced by a W.T. Grant store. Later, World Drug moved into this location, and currently the reworked store is used as an off-site campus of Illinois Central College.

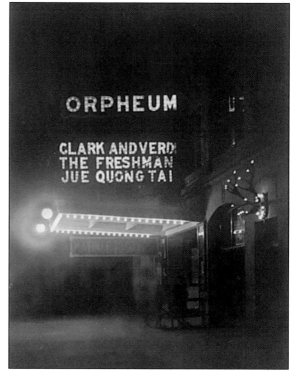

Shown here is the Orpheum Theater's marquee as it appeared the night of October 28, 1915, for the evening's live performance of Clark and Verd, the Freshman. This theater was constructed by the Leisy family and opened April 24, 1911. The theater was never converted to accommodate motion pictures and eventually closed in 1927. The entire structure was demolished in 1952.

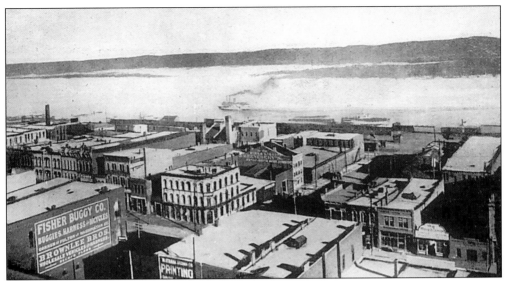

The center building captured in this 1907 postcard is the Commercial National Bank, located at the corner of Fulton and Washington Streets. The bank was reorganized in 1885, and remained at this location until its move to 321 Southwest Adams in 1909, when the Bennett Building was completed. From 321 South Adams, the next move was to 301 Southwest Adams. The Fulton and Washington Street building was destroyed in 1938, and the area is known today as the " 'Sears' Block."

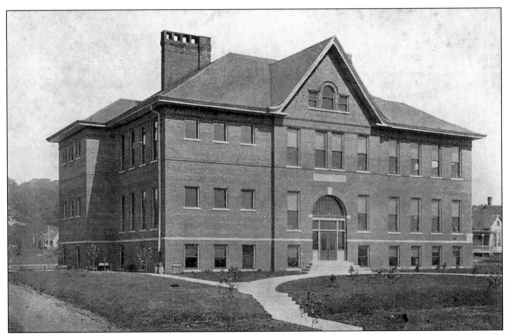

This postcard shows the Kingman School, which opened in the village of Averyville June 17, 1903. This building remained until 1928, when the City of Peoria annexed the area, and the school became part of District 150. The building had an addition in 1906, and again in 1909. Kingman School functioned as a high school until Woodruff High School was opened in 1936. Kingman is now a grammar school.

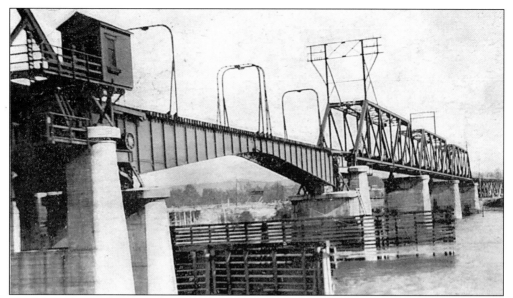

The McKinley Bridge was opened the same year this postcard was mailed in 1910. The electric railway constructed by the Illinois Traction System to Peoria was completed in 1907. The system connected Peoria with St. Louis and Danville, and was the longest electric railway system in the United States. The passenger service to Peoria was discontinued in 1950.

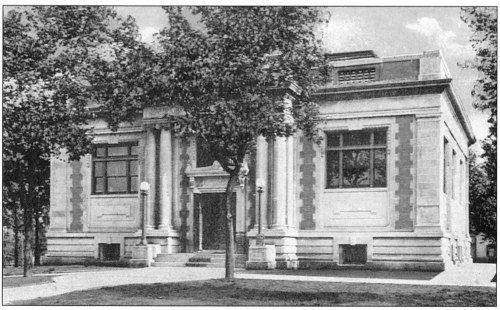

The Lincoln branch of the Peoria Public Library system was a gift to the city from Andrew Carnegie, who financed the construction in 1911. Carnegie, a multimillionaire philanthropist, assisted cities across America in promoting local libraries. This building is located in the center of the Eads Farm, and is currently known as Lincoln Park. The site had also served as the city cemetery, but was abandoned as such by 1880.

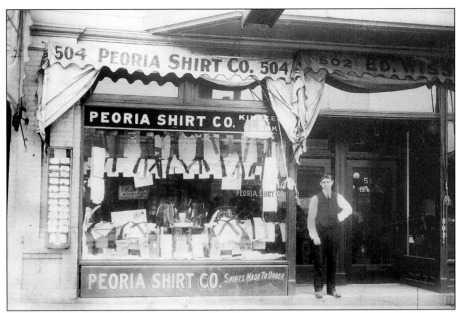

The Peoria Shirt Company occupied 504 Main Street beginning around 1905. The postcard image above was taken in 1912. This storefront was the added facade to the former First Presbyterian Church, which was previously located on the corner of Main and Madison. After the congregation built the new building in 1889, this building was sold. Kintze and Clark, the owners of the Peoria Shirt Company, used the former church auditorium as a work area. The Shirt Company moved next door in 1918, when the former church building was removed to make room for the Madison Theater. This business closed in 1942.

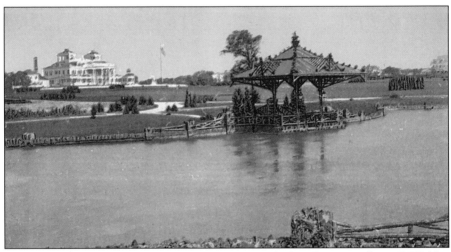

After Joseph B. Greenhut sold his mansion at High and Sheridan to William F. Wolfner, he moved to Shadow Lawn, pictured above, in Long Island, New Jersey. Greenhut was one of the creators of the Whiskey Trust and one of Peoria's leading citizens. In 1915, this residence was referred to as the "Summer White House," because Woodrow Wilson stayed there as Greenhut's guest. After he left Peoria, he purchased the largest department store in the world—the Siegel Cooper Company. The store became known as Siegel, Cooper and Greenhut, and closed in 1918. Greenhut died in 1918, and Shadow Lawn was destroyed by fire in 1927.

The caption on this 1910 postcard reads, "Lover's Seat in Glen Oak Park, Peoria." Glen Oak was originally established as Birket's Park, and spanned 106 acres. This park was one of the most popular public recreation areas for Peoria, providing winter and summer activities alike. However, the summer activities have increased over the years as Peoria citizens return to this old park.

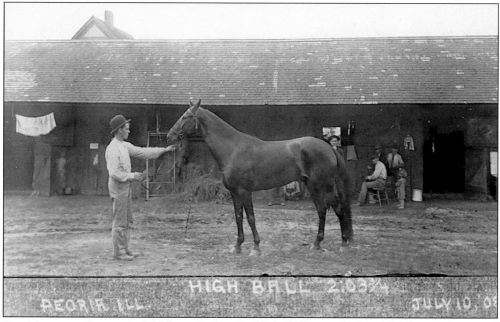

Peoria's racetrack record of 2:05 was broken by High Ball's speed of 2:03.75 during the Grand Circuit visit in 1908. The track in Peoria was one of the three fastest courses in America. High Ball's visit proved to be a peak in racing for this area.

One of the main objectives of the opening of Glen Oak Park was to provide many park activities—both large and small. Pictured here is a 1910 view of the summerhouse. Unfortunately, most of the wooden structures like this one were removed by the 1950s, leaving few reminders today of these popular attractions to Glen Oak Park.

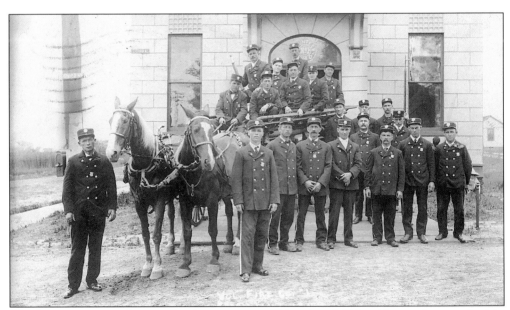

The last remaining volunteer fire department at Grinnel and Griswald was photographed in 1909, just three years before they were disbanded. The City of Peoria annexed the Village of South Peoria in 1900, and the two volunteer firehouses here remained until Firehouse #1 was disbanded in 1909, and Firehouse #2 in 1912. This building had also served as the village hall, and was removed in the 1950s.

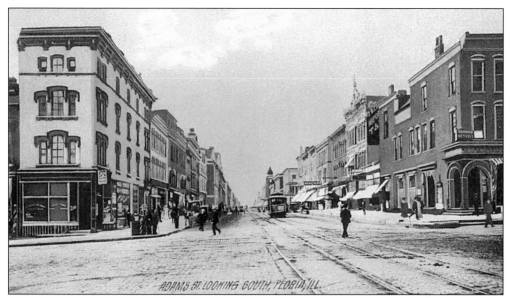

Pictured here is Southwest Adams at Main Street as it appeared in 1900. The right side of the picture shows the Central National Bank that occupied this location beginning in 1893. This building also was referred to as the Rouse Building. The left side shows the McDougal Drug Store, which remained until the building was removed in 1922 to make way for the Clark Company expansion. Unfortunately, all buildings on both sides of Adams have since been destroyed and replaced.

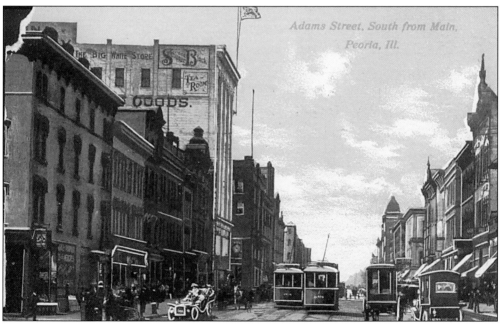

A view of Southwest Adams and Main is pictured above in 1911. The producer of this card manipulated the photograph a bit by inserting wagons, early autos, and streetcars. The large Schipper and Block Building is shown in the middle and to the left, and is the only building in the photo that still stands today.

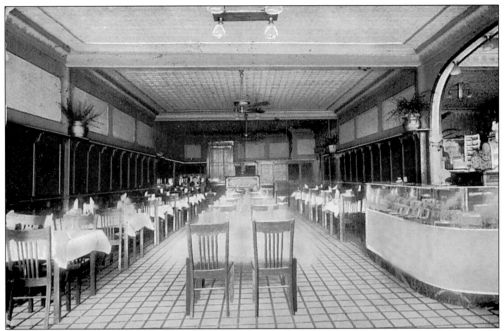

This is the Gmelich Restaurant as it appeared in 1910 at 323 Main Street. This location was so successful that another location was opened around the corner at 109 Southwest Adams, but this proved to be short-lived. In the early 1920s, both downtown locations were closed. Thompson's Restaurant later occupied the Main Street location, and the Adams location became W.T. Grant & Company.

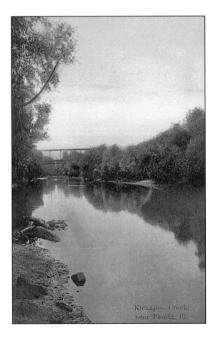

The Kickapoo Creek Bridge on Farmington Road, is shown as it appeared for many years until its replacement in 1935. Although Peoria is situated in the center of the Prairie State, the river and hills provide a break from the vast Illinois prairie. Beautiful views are to be found in every direction.

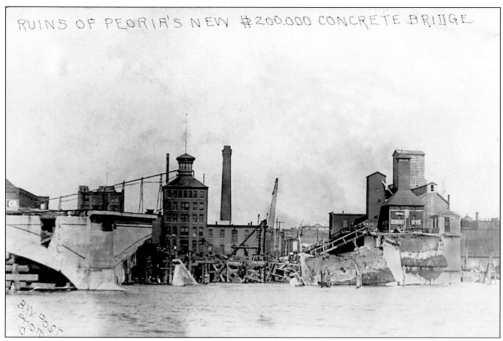

RUINS OF PEORIA'S NEW $200.000 CONCRETE BRIDGE

B.W. Post captured the destruction of the collapsed Franklin Street Bridge in this photo as it appeared on May 1, 1909. Also shown in this card is the silhouette of the Gipps Brewery, which was founded by John M. Gipps in 1881. The building was destroyed with the construction of the Bob Michael Bridge in the middle of the 1990s.

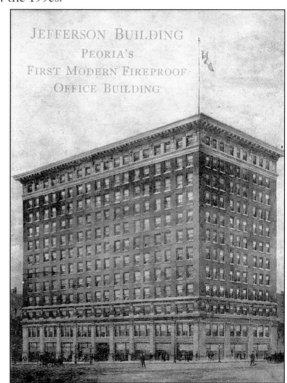

A proud new tenant of the Jefferson Building announced to their customers the location of their business in this new building. The postcard was mailed April 26, 1910, and the business was assigned to rooms 609–611. This building still stands today at the intersection of Jefferson and Fulton Streets.

43

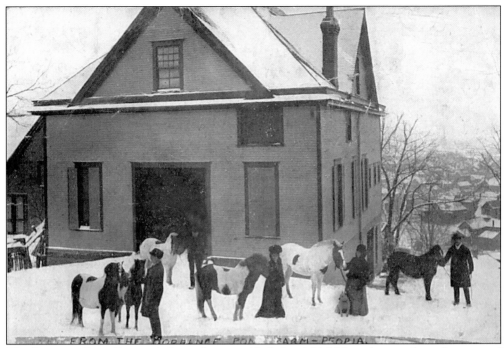

The Dorrance Pony Farm was located in a stable behind 816 Moss Avenue from the years of 1898 to about 1915. Raising ponies was a new industry in Peoria at that time. This residence was known as the Clark home, and Mrs. Lydia Bradley lived next door.

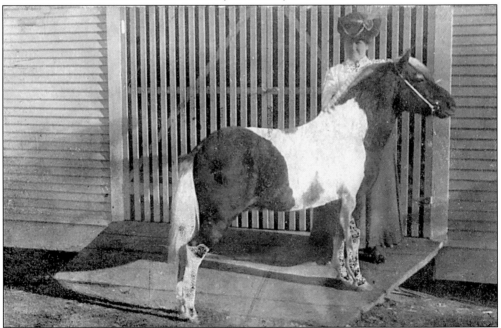

Marguerite Dorrance is pictured here next to one of her prized ponies. The background shows the doors to the stable. This structure was three stories tall, and the lower level sloped down the hill. The street level held numerous carriages, the next level was the coachman's residence, and the top floor was the hay loft and feed storage. This building no longer exists.

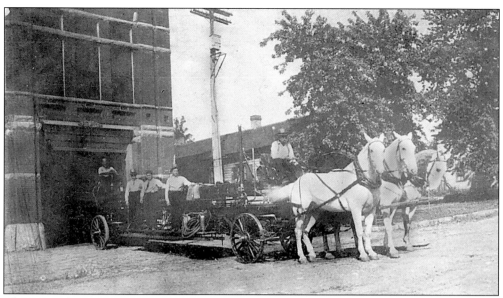

The Central Fire Station was located in the middle of the block on Spalding Street between Adams and Jefferson. The alley was referred to as Fayette Court. Firemen are pictured here with the aerial truck driven by horse in 1907. This building had three doors—two more are located to the left. The height of the building was two and a half stories. The use of this building as a fire station ceased in 1922. By 1932, the Peoria Players had taken charge of this facility and connected it to the playhouse. They remained there until the building was demolished in preparation for routing Interstate 74 through Peoria.

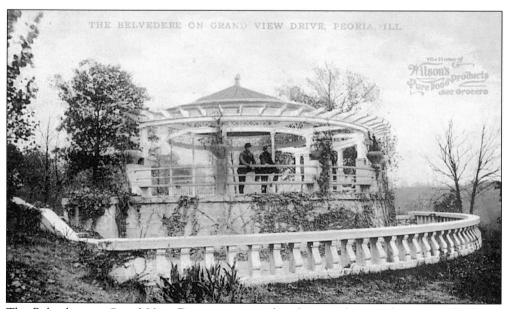

The Belvedere on Grand View Drive was a popular place to photograph a postcard subject. However, in 1915, the Wilson Grocery Company inserted their trade name and logo. The card attracted attention, and the message sold their product. The message printed on the back was designed to advertise their Wilson Breakfast Coffee.

This street scene is photographed from the lawn of the Peoria County Courthouse in 1910. Facing Southwest Jefferson, all of the buildings pictured either burned out or were demolished within a decade. The former home of Dr. Rudolphus Rouse is shown in the middle. The house once faced Main Street, and one side was on Jefferson. Dr. Rouse built an addition to the northwest side of this residence, thus creating Rouse Hall, which became the Main Street Theater around 1900. Both buildings were removed in 1918 to make room for the Peoria Life Building. Behind Dr. Rouse's home was the home of John Hamlin, with an added business front. This building was destroyed by fire in 1916. The Dime Savings is shown to the far left with the two-story pillars.

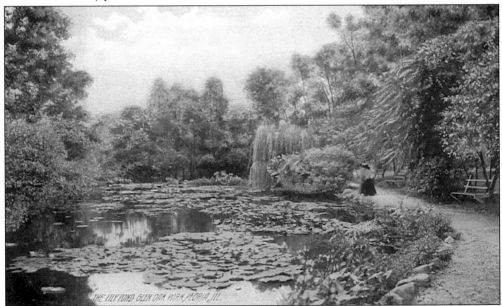

The Lily Pond in Glen Oak Park was a reminder of late Victorian attractions built by the park board for the citizens of Peoria to enjoy. This scene was in 1907, and the card was exchanged with a postcard collector in New Jersey. After many years, this card finally made it back to Peoria.

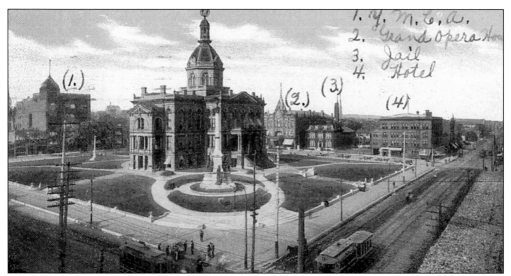

An Act of Congress in 1907 provided the ability for a message to appear along with the address on a postcard. However, the author of this card in 1906 provided the receiver, Miss Helen Grose of Albany, New York, a quick glimpse of the layout of Peoria County Courthouse and the sites around it.

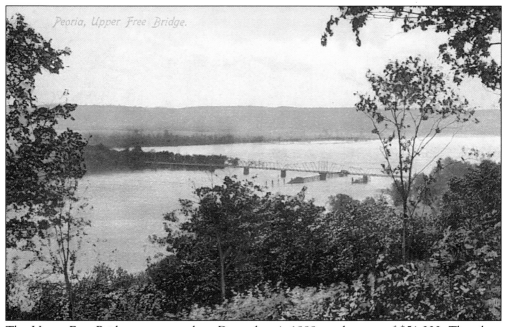

The Upper Free Bridge was opened on December 4, 1888, at the cost of $51,000. The plans were drawn by George F. Wightman, city engineer, and the work was done under contract by Lewis, Wood, and Tenney. A parade was led from downtown to the "Narrows" at the foot of Lorentz Avenue, or Bridge Approach. This span remained in service until it was struck twice by the towboat *Sylvia T*, in February and May of 1943. The second hit in May rendered the bridge a total loss. The War Department removed the wrecked bridge in 1947. The west side pier remains today and may be seen from the McClugage Bridge.

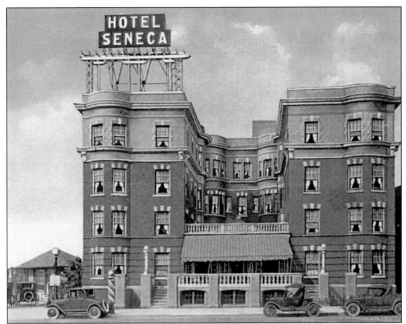

In 1904, Robert Hotchkiss, a Peoria architect, built these courtyard apartments on the west side of Franklin just north of Second Street. In 1920, G.H. Sommer remodeled the complex into a hotel and raised the roof to provide a fourth floor, and a one-story addition filled in the courtyard area to provide a lobby. This new hotel was named The Seneca. George Brosius took over the lease in 1926, and on February 11, 1936, the building burned. The badly damaged remains were razed that same year, and a Super Service Station was built on the site.

Cottage Hospital was an outgrowth of the Peoria Hospital Association, who saw the need for another hospital in Peoria around 1883. This association acquired a residence at the corner of Second and Fisher Streets and converted it into a 50-bed hospital. A three-story brick addition was added to Cottage Hospital in 1893. A new stone and brick building four stories in height was constructed and occupied by 1902, and before the year was out, another floor was added. This increased capacity brought the facility to 110 beds. John C. Proctor, the principal benefactor, died suddenly in 1907. The board then changed the name to Proctor Hospital in his honor. This institution relocated in 1959 on Knoxville.

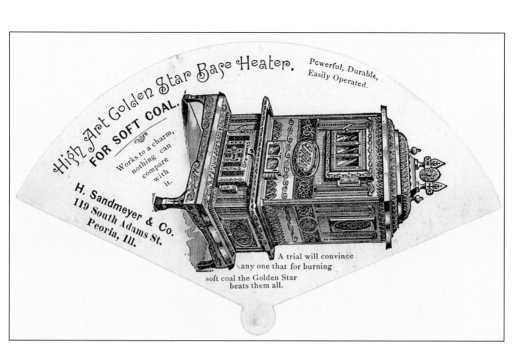

H. Sandmeyer & Company sold High Art Golden Star Base Heaters, pictured in this fan-shaped postcard. They boasted that the product was "powerful, durable and easily operated." It "worked to a charm that nothing could compare with." They stated that a "trial would convince anyone that for burning soft coal the Golden Star beats them all." The company was located at 119 South Adams Street at the turn of the century.

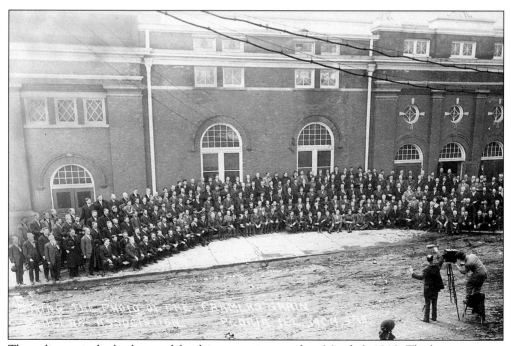

The coliseum is the background for this group picture taken March 3, 1910. The honorees were attending the annual meeting of the Illinois Grain Growers Association. This building was located at the corner of Northeast Adams and Hancock. A fire in 1920 destroyed the building.

Brick streets in Peoria have nearly disappeared under pavement. The cost of maintenance has risen over the years. This brick street is identified as Garfield Street, south of Main Street in 1912.

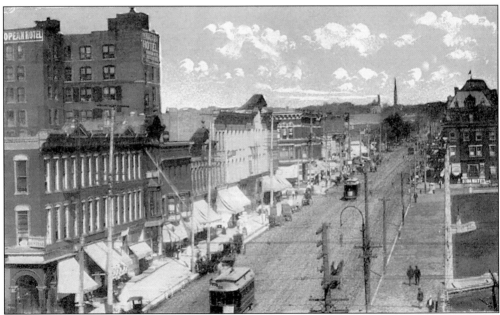

This picture shows Main Street's three hundred block as it appeared in 1910. The building to the far left, the Rouse Building, was removed four years later to accommodate the Central National Bank in 1914. The former public library building is shown in the middle of the card facing Jefferson Street. Towering above all is the Niagara Hotel, which was destroyed in 1968.

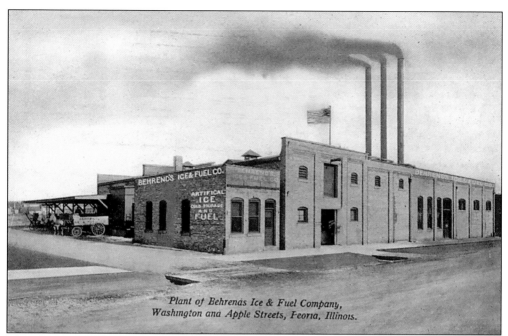

Plant of Behrends Ice & Fuel Company,
Washington and Apple Streets, Peoria, Illinois.

The plant of the Behrends Ice & Fuel Company at Washington and Apple Streets is shown here in 1915. In the manufacture of artificial ice, it was necessary to remove the air and impurities from the water to be frozen in order to produce a pure ice. This was done by thoroughly distilling and purifying the water before freezing. The capacity was 125 tons of ice daily. By 1917, Behrends became Citizens Ice and Cold Storage. In 1929, Citizens, along with two other companies, became Peoria Service Company.

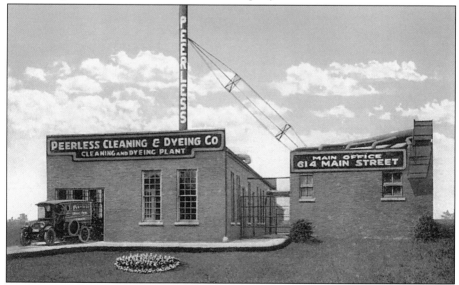

The Peerless Cleaning and Dyeing plant was located at 209 Glendale Street, as shown above. The receiving area and office was located at 614 Main Street. The firm operated as a processing plant on Glendale across from the YMCA, and remained there well into the 1950s. Its name was changed to Columbia Peerless Cleaners and Dyers, and it eventually closed in the early 1960s.

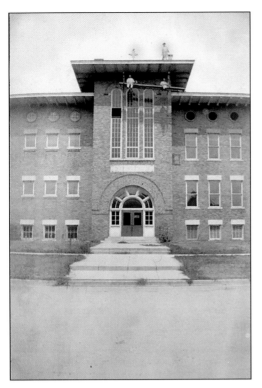

St. Mary's School was five years old when this card was mailed. The writer of this card is pictured painting the school windows, and the receiver of the card had to guess which one was the friend. This building was done in the new Midwestern style of architecture called American Prairie. This school closed in 1967, opening again for a short time and closing finally in 1975. The building was destroyed in 1978.

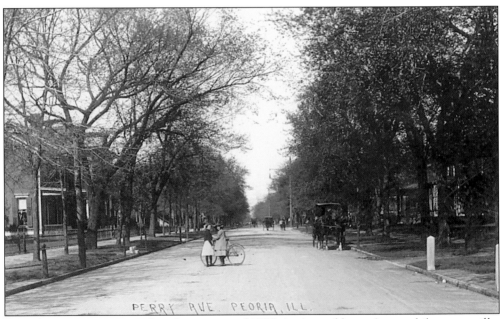

Perry Avenue, as it appeared in the summer of 1905, is pictured here. Automobiles were still a toy for the rich, and children were still able to play in the street freely. Sleigh bells jingled and hoof beats could be heard on this residential street during the winter months. However, this same gravel street was also a racetrack for speedsters. Later, Perry Avenue gave way to Jefferson Street between Wayne and Hamilton as the new "racetrack."

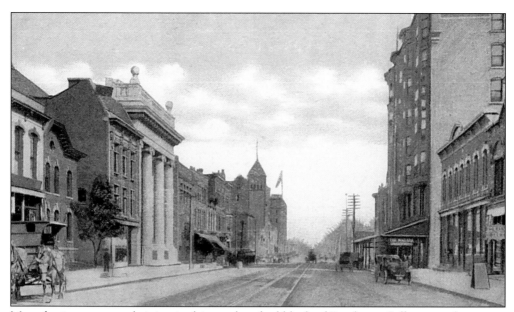

Many businesses were thriving in this one hundred block of Southwest Jefferson in downtown Peoria. Commanding an imposing view to the middle left was the columnar Dime Savings and Loan building. To the right was the Niagara Hotel, and next to the alley was the Pete Weast Building at 120–124 Southwest Jefferson. All buildings on both sides were lost to the wrecking companies.

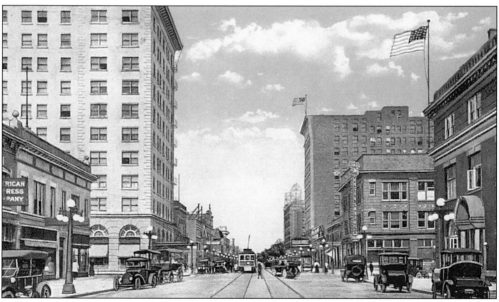

Jefferson Street was overrun with automobiles and streetcars by 1920. To the left was Peoria's finest new hotel, the Jefferson. This hotel was built in 1912 and named for the street. Shortly after the opening, two additional floors and an annex were added. Construction on the Jefferson Building to the right began in 1909. This building still stands today. The middle right shows the State Trust and Savings Bank. Later, this same building at 240 Southwest Jefferson became Brown's Business College, then the Midstate College of Commerce and, today, the First Bank.

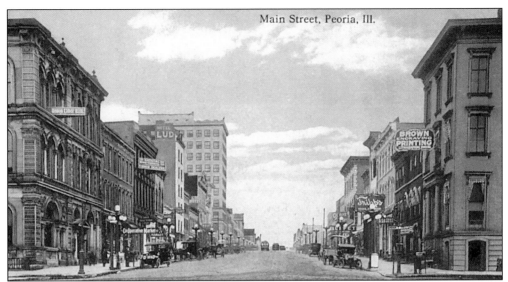

Main Street, Peoria, Ill.

This well-known 1915 stretch of Main at Washington Street indicates the many Peoria retail businesses in the 100 block of Main. The building to the far left was home to the German American National Bank built in 1888. This location at 204 Main Street became the Larkin Store in 1902. By 1937, Piggly Wiggly occupied the space. The Lud Hotel was located at 217 Main Street (middle left), with the light-colored front, in 1904. To the right was Brown Printing Company; this was originally built for the First National Bank at 210 Main Street. To accommodate the World Headquarters for Caterpillar Company in the 1960s, the right side of the block was leveled.

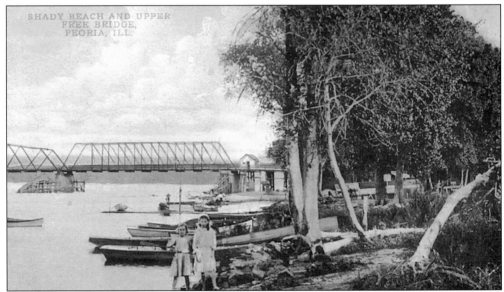

The Shady Beach and Upper Free Bridge as they appeared in 1911 are pictured here. The Upper Free Bridge was opened for service December 4, 1888, and had cost a mere $51,000. George Wightman, city engineer, drew the plans, and Lewis, Wood & Tenney completed the work. This span remained in service until it was struck by the towboat *Sylvia T* on February 27, 1943. After several repairs and similar accidents, the bridge was abandoned. The parts of the wrecked bridge were finally removed in 1947.

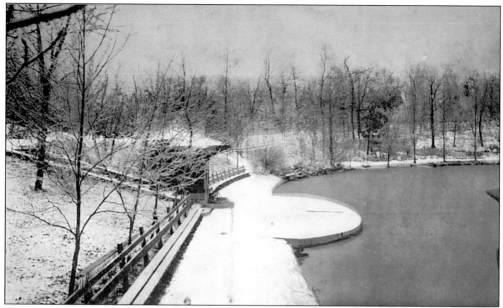

The boat landing was a photographer's dream in the winter of 1910 at Glen Oak Park. Opened in 1902, a boat could be rented for 15¢ an hour. The size of this lake is 4.5 acres. After many changes and fill-ins, the lake remains, but is much smaller.

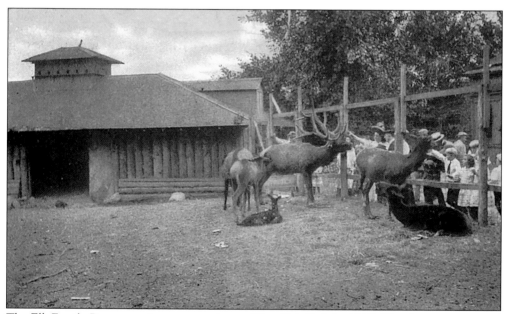

The Elk Family Pen was quite an attraction to Glen Oak Park by 1910. This deer pen attracted many visitors, as shown above. The animals prospered to the point of forcing the park system to sell and trade, thus reducing the animal populations. In the late 1930s, the desire to establish a zoo was surfacing. Today at Glen Oak Park you'll find the zoo, baseball diamonds, lagoons, playgrounds, and various other attractions.

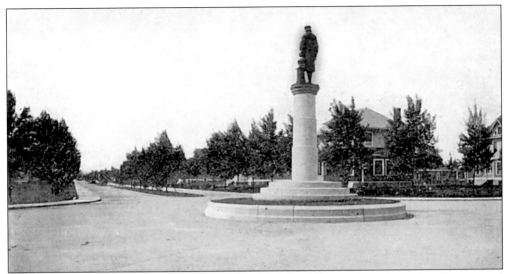

This statue of Christopher Columbus now stands in Bradley Park at Columbia Terrace and Parkside Streets—a final home for this statue. It was manufactured in Salem, Ohio, by sculptor Alfons Pelzer before 1893. The Columbia Exposition of Chicago was the original destination of this statue along with four additional statues of Columbus. The Upland subdivision developer, Briggs Real Estate, acquired the statue and placed it, a 9-foot likeness of Columbus, on top of a 22-foot pedestal at the intersection of Columbia Terrace and North Institute Place in 1902. After a short storage period and a restoration by Nita K. Sunderland, Columbus was rededicated in 1984 at its present location.

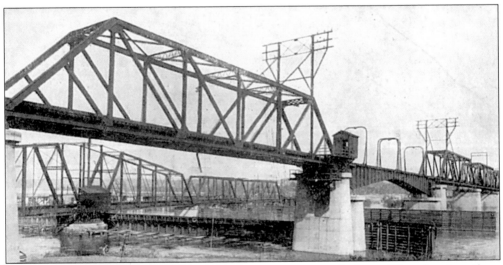

In 1907, the McKinley Bridge opened for service as pictured above. The electric railway constructed by the Illinois Traction System officially entered the city of Peoria and offered services to St. Louis, and as far as Danville, Illinois. The system in Peoria closed by the early 1950s.

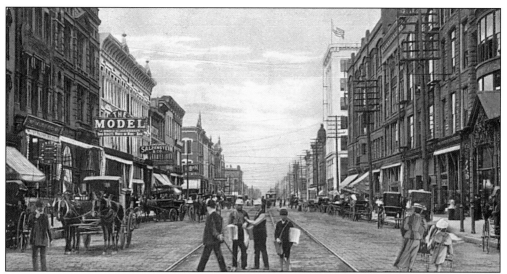

The three hundred block of Southwest Adams as it appeared in 1907 is shown here. Automobiles were still scarce, and this street was shared by street cars, horse-drawn buggies, and people. The Schipper & Block Building may be seen to the middle right, along with the Woolner Building (later known as Bergner's Store). The Woolner Building was removed to make way for the Tech Center in the middle 1990s. To the left are the Model and Salzenstein Companies. By the 1990s, all of these buildings, except Schipper & Block, were razed.

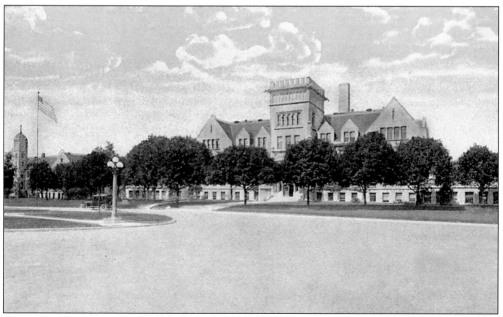

Camp Bradley at Bradley Hall is here at Bradley University in 1918. Special training courses were conducted on campus during WW I through arrangements with the federal government. In April of 1918, Camp Bradley began training the first of two thousand men. By the end of the First World War, 1,831 men had received specialized military training.

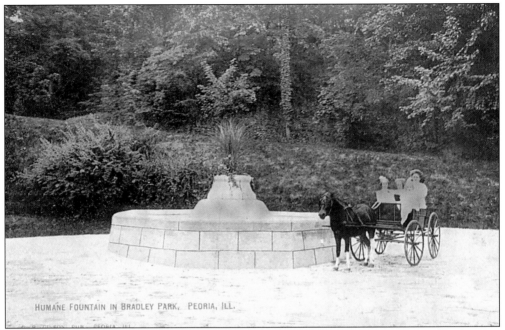

HUMANE FOUNTAIN IN BRADLEY PARK, PEORIA, ILL.

This unidentified family is pictured in 1909 by the Humane Fountain in Bradley Park. This type of fountain was placed in several parks during this time period. Transportation was changing, which triggered the removal of these plain but dignified fountains.

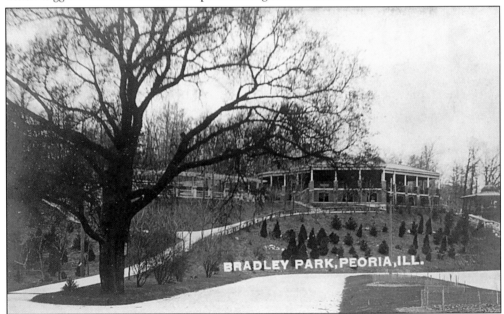

BRADLEY PARK, PEORIA, ILL.

The pavilion pictured above was built in 1904. The bandstand, which took its design from an Oriental pagoda, is also visible. It was built with iron and copper railings. For many years, crowds enjoyed the hilltop retreat, and band music was heard all around the valley. The middle left shows the wooden pagoda. Mrs. Bradley provided a large basin inside the pagoda for all to enjoy. A combination of decay and the effects of time took their toll on the complex, and it was removed in 1966.

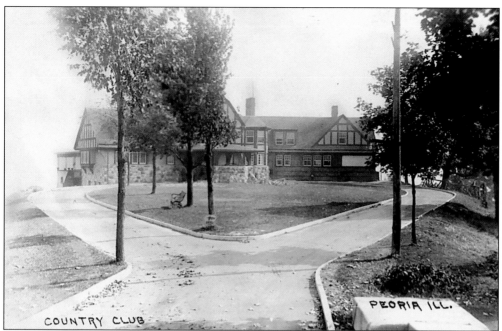

The Peoria Country Club erected the clubhouse shown above upon removal of the original clubhouse, which was included with the purchase of the original 27 acres, known as the Caroline S. Gibson property. This building was newly constructed when this card was postmarked in 1908. Fire destroyed it around 1920, and a new clubhouse was built for $187,000. It opened in July of 1922 and still remains today.

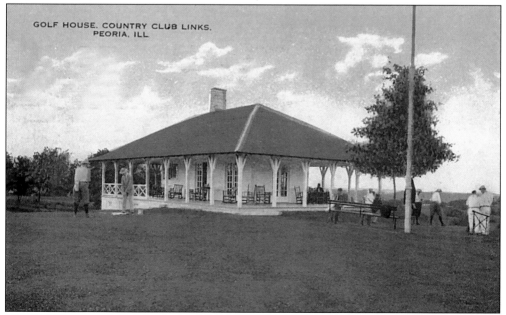

The Golf House and Club Links is pictured here as it appeared in 1915. This building was quite an addition to the nine-hole golf course that the country club provided to its members. The club provided a magnificent view of the Illinois River Valley and of a distance of up to 30 miles. The Golf House is not standing today.

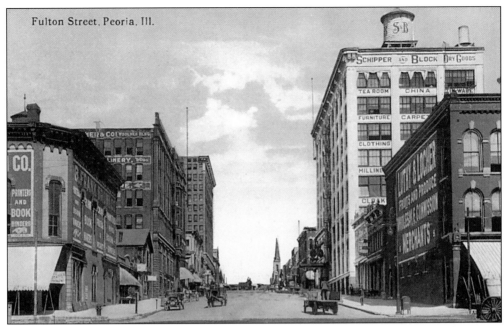

The corner of Fulton Street at Washington is pictured in this card, which was mailed in 1913. Block & Kuhl took over this imposing building at the upper right corner of this card from the department store known as Schipper & Block. The building in the lower right corner of the card was the Luthy and Locher Produce Company. The Betty Brown Dress Company occupied the upper two floors. The companies were forced out of the building when it was destroyed by fire on March 22, 1929. Luthy and Locher closed in the early 1970s.

Joseph P. Greenhut's contribution of $15,000 made it possible to complete the GAR Hall, located at 416 Hamilton in 1909. The Army of the Republic responded by naming the hall the Greenhut Memorial. The hall is maintained today by the Central Illinois Landmark Foundation.

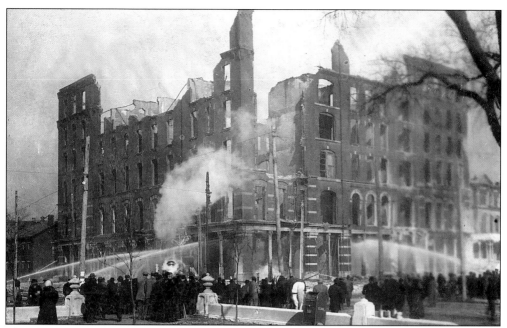

The National Hotel once stood at the corner of Hamilton and Jefferson Streets. The hotel was partially burned in 1893, and a sixth floor was added during the reconstruction. Unfortunately, the building was lost to fire on November 13, 1911.

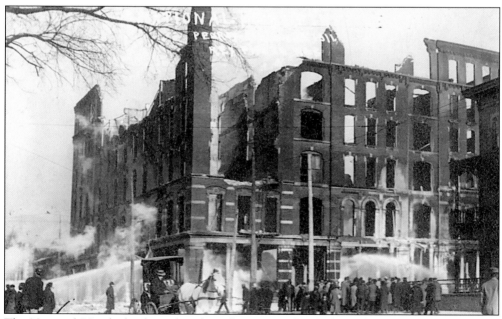

The National Hotel, the finest hotel in Illinois outside of Chicago, was built in 1886. This building had five stories prior to the fire of 1893. After the fire in 1911, the hotel opened next door at the former Ingersoll Hotel in 1920. It became known as the New National Hotel at 217 North Jefferson, and was finally razed in 1970.

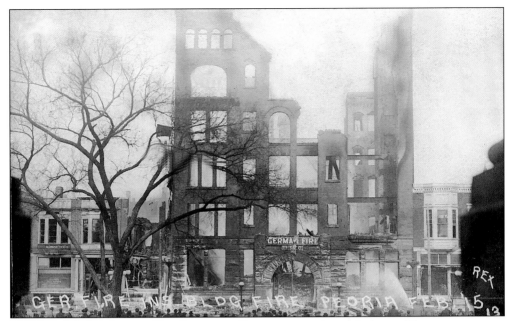

The ruins of the German Fire Insurance Company are pictured above. The company was located at 115 North Jefferson beginning in 1909. The six-story building had been constructed for, and used by, the YMCA in 1890. This building was lost in a fire on February 28, 1915. The damages were estimated at $180,000. The building was replaced with the two-story Rehfuss Building, which was a mere shadow of the German Fire Insurance Company building.

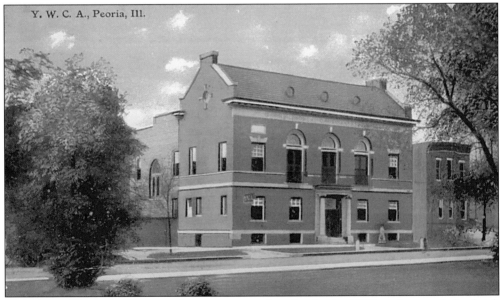

The Young Women's Christian Association purchased a lot in 1905 and erected the brick building shown above at 411 Liberty Street. This new home for the YWCA was dedicated on New Year's Day of 1909. The Association outgrew this facility by 1925, and the property was sold for $75,000. The Elks Club then occupied the building until it was lost during the Depression. After the war, the Illinois Mutual Casualty Company remodeled the building for their use. The building was razed in 1979 to make way for the new civic center.

Three

1921–1940
THE PROSPEROUS TWENTIES, GROWTH, AND DEPRESSION

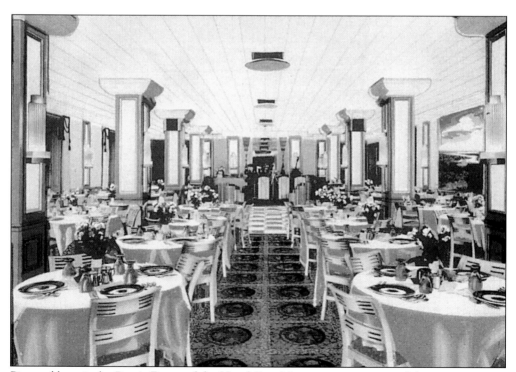

Pictured here is the Peoria Room of the Hotel Pere Marquette as it appeared during its opening in 1927. Food was served regularly in the Peoria Room and the coffee shop nearby.

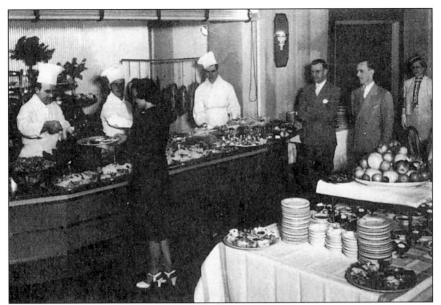

This postcard is of the smorgasbord at the Hotel Jefferson in 1940, and it was mailed to a local Peorian. The mailing of this card was also used to advertise the coming attractions at the Hotel Jefferson Opry House, such as "Adrift in New York," "Her First False Step," and "The Show That Broke Your Grandpa's Heart." The shows were available every night except Monday. The Jefferson Hotel was removed in 1979 to make way for the new civic center.

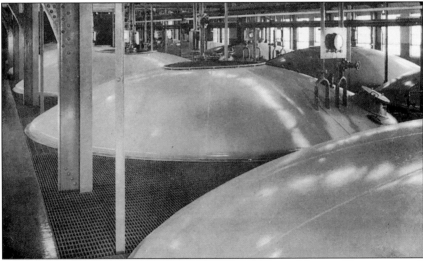

Hiram Walker & Sons was led to Peoria through the efforts of former Congressman William Hull in 1933. After its construction, this plant was quite a bonanza on the Illinois River at the time of the Great Depression. Hull remained as general manager until his death in 1942. This partial view of the 24 giant fermenters, which enabled Hiram Walker to make wonderfully fine whiskies without long aging processes, is quite impressive. The largest, most modern distillery in the world was making over 2,000 barrels or 100,000 gallons, of whiskies and gins per day, and bottling 25,000 cases for the market. Hiram Walker's distillery at Peoria used 90,000 bushels of corn and rye, 13,000,000 gallons of water, and 400 tons of coal every 24 hours. ADM took over this plant in 1982.

The Rome Seawall is the principal object of the postcard above. The highway lies just beyond the wall. This roadway was Section C of the Peoria-Henry Highway, which was constructed in 1920. This road today remains virtually intact—unchanged except for some resurfacing, but it has never been widened, realigned, or straightened.

The small village of Rome, which is located north of Peoria, was once a thriving river town on Route 88. The village was laid out in 1832 by Jefferson Taliafero, and was probably named for either Rome, New York, or Rome, Italy. The town pictured in this 1930s postcard captures the tranquil small town that once aspired to become the Peoria County Seat.

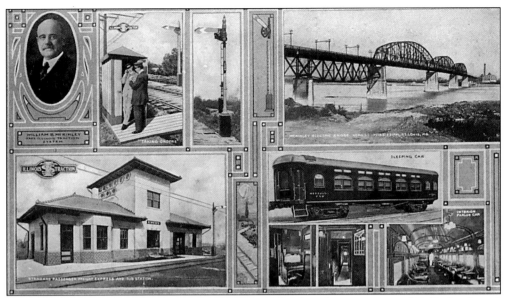

Illinois Traction entered the Peoria market in 1907. This electric railway (McKinley Lines) constructed its own Mississippi River bridge in 1910. Rail service via the electric cars even provided overnight accommodations to its terminal in St. Louis. The early 1950's marked the withdrawal of this type of rail service from Peoria.

This card was mailed in 1920, and the writer's message was, "I guess not—it is 2:00 A. M.!"

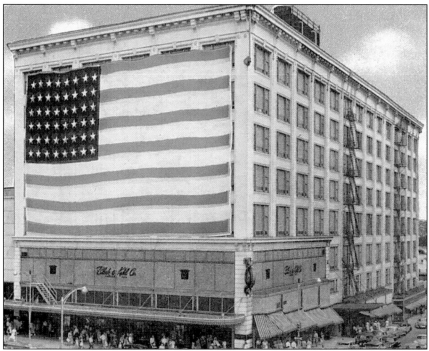

The largest American flag in the world, maintaining its true proportions, is displayed above. Block and Kuhl purchased this huge flag from Annia & Company of Verona, New Jersey. A blend of wool and nylon was the formula for the production of such a huge flag. The first time the flag was displayed was Memorial Day, May 28, 1952. The stripes each measure 4 feet in diameter. The flag measured 90 by 60 feet and weighed over 400 pounds. The flag was displayed using permanently installed bolts so it could be tied down. Shortly before 1959, the flag was retired and never seen again.

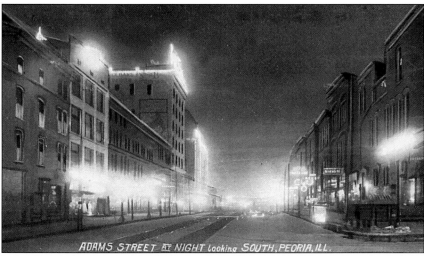

This photo shows the one hundred block of Southwest Adams as it appeared shortly after the installation of street lights. This night scene was around 1910. Many stores had already installed their own lighting, as demonstrated by Block & Kuhl (middle left) and the Woolner Building (center).

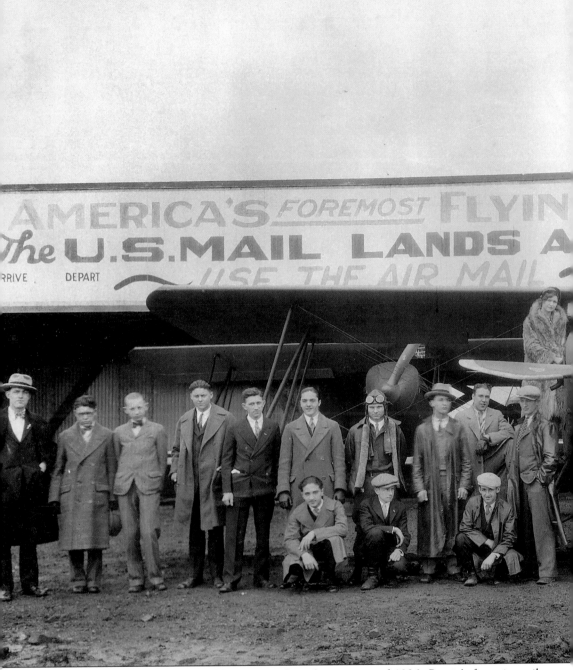

The Big Hollow Airport, or Field #2, opened in the summer of 1926. Peoria's first air mail delivery by Charles A. Lindbergh arrived Aril 15, 1926, at Kellar Field, which is known today as the High Point subdivision. Alex Varney of Des Moines became the principal spokesman of aviation within 100 miles of Peoria. In 1926, Varney organized the Varney Aircraft Company and expanded his flight school. The developing area around Kellar Field, Peoria's first airport, forced Varney to relocate his school to the new location, which is pictured above. This became

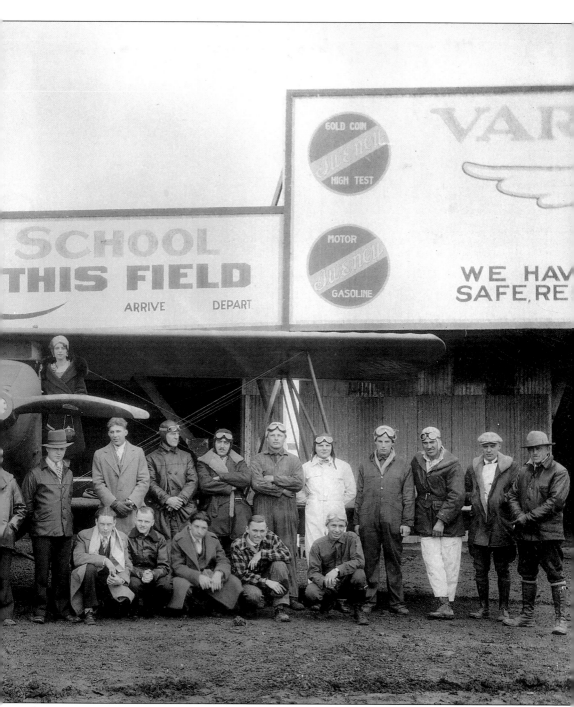

known as Varney's Big Hollow Airport. This new field opened in 1926, and Kellar closed. Ken Rinle, Tony Amrhien, and Slim Carson did the carpentry work at the new hangar. The land was leveled, and flights began. Air mail flights to Peoria arrived at this location. The Big Hollow Peoria Airport soon was unable to accommodate the increasing demands on this new Peoria industry and closed in 1930. The present airport opened in 1932.

The McKinney School of Hawaiian Guitar assembled its students for an annual event held at Majestic Theater in the late 1930s. P. McKinney taught several instruments from his store location at 124 North Madison.

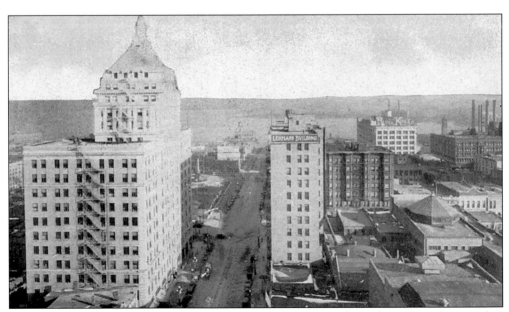

The four hundred block of Main Street as it appeared in 1949 is shown here. The photographer was using a Pere Marquette Hotel room as his vantage point. The buildings to the right of Main Street were destroyed in the 1990s, except the Block and Kuhl building, which is now Bank One.

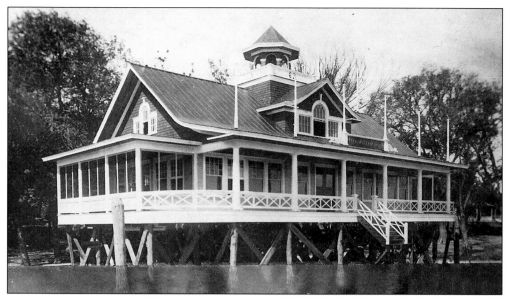

The Ivy Club was composed of four boating clubs active in Peoria. A swimming program, dining room, boat storage facility, and a large harbor were provided with membership. The club was organized in 1907, and constructed the building pictured above the same year. The pilings served as a base for the clubhouse, which was built on the water's edge. By 1927, the organization reorganized, and the club moved upstream to a new riverfront parcel. The clubhouse was moved and placed on a new brick foundation, and it appears much the same today as in 1927.

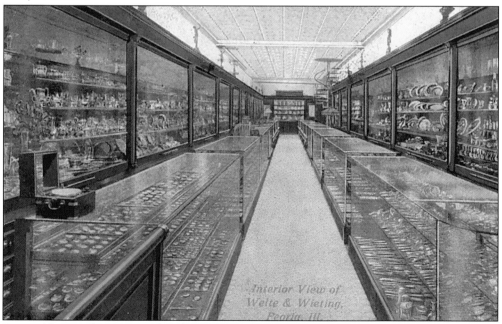

Pictured here is the interior of Welte & Wieting, jewelers, as their showroom appeared in 1920. They opened for business around 1905 at 112 South Adams and remained at this location until 1920, when they moved to 216 South Adams. The firm ceased operation in 1935 at their final location, 115 Jefferson Street.

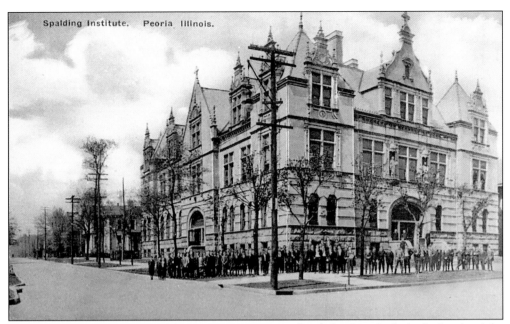

Spalding Institute. Peoria Illinois.

When it opened in 1899, Spalding Institute was considered the first Catholic high school for boys in the West, and only the second in the United States. This school was named for Bishop Spalding's brother, Reverend Ben J. Spalding. By 1906, the decision was made to focus on high school students, and the preparatory class was eliminated. The above picture, taken in the 1920s, captured students facing the camera—the people remain unidentified. Spalding Institute remained academically and athletically strong, and merged with the Academy of Our Lady in 1974. Finally, in 1988, this school united with Bergan to form Notre Dame High School. These buildings still stand and are used for church-related activities.

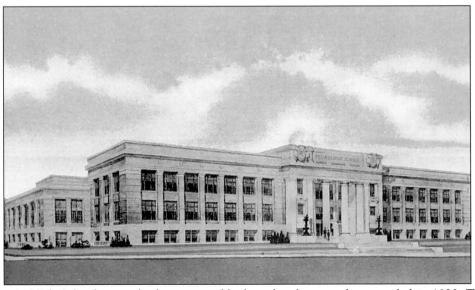

Peoria High School was only three years old when the above card was mailed in 1920. The building is located at 1615 North Street, and is now known as Central High. It proudly serves the community today as the oldest high school in Illinois, and the 17th oldest in the nation.

The Madison Park Golf Course as it appeared in 1923 is shown here. This course, consisting of 86 acres, was outside the city limits when it was acquired in 1894. The park was Peoria's first nine-hole golf course, and it opened in 1909. Frederic J. Klein designed the pavilion in the background, which was completed in 1915. Both the Peoria Police and park police used a portion of this park as a rifle range. The final acreage acquired totaled 163 acres. Madison Park differs completely from its sister parks in that it is used almost exclusively for golf playing.

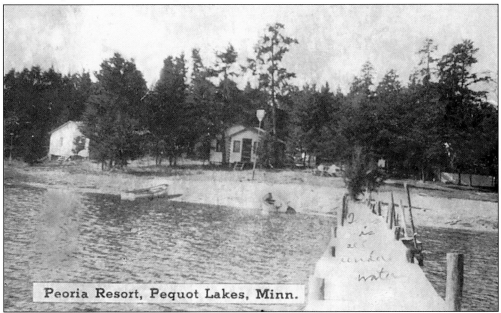

Peoria Resort, Pequot Lakes, Minn.

It always seems fun to discover the use of the name Peoria in states other than Illinois. The above postcard is a departure from other cities named Peoria. This small resort provided postcards for its guests. The card was mailed to Peoria in 1936, and this specific resort still operates and provides postcards today.

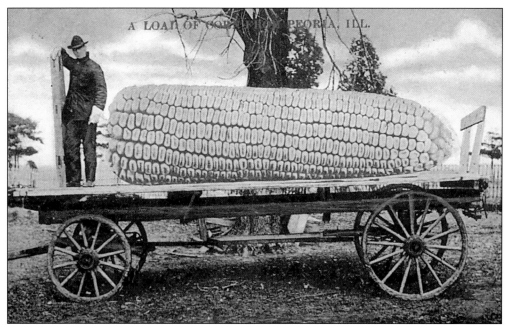

The "Load of Corn" is what collectors refer to as a "fun card." Peoria is located in the heart of Central Illinois and the Corn Belt. The advantage to manufacturers of this type of card was the ability to add the names of other cities, reprint and market them in a different area.

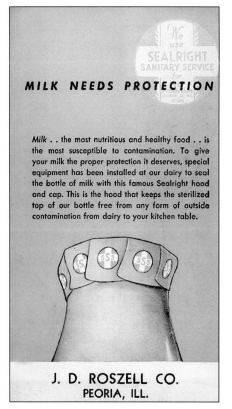

The J.D. Rozell Company opened a milk depot on Madison in 1894. By 1925, the company relocated their plant to 736 Southwest Washington. The National Dairies Corporation purchased Rozell's in 1930, and merged the plant into the network of local dairies. In 1935, Sealtest Systems was initiated at Rozell's. This was a system of creating a standard milk product nationwide. The Rozell name was later retired, and the company converted all its dairies to Kraft, Incorporated Dairy Group plants by the 1970s. The Peoria plant was finally closed in 1987. Phillip Morris Company purchased Kraft, Inc., and the companies were merged, just as Rozell's had done nearly 50 years before.

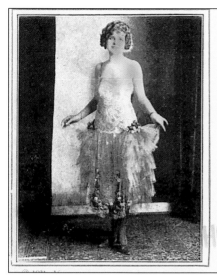

Peerless Cleaning and Dyeing Company was located at 614 Main Street beginning in 1910. Note the manner in which companies would alter their advertising postcards. The telephone number would change from three to four digits and was stamped on existing material. The Main Street office of Peerless closed in 1937.

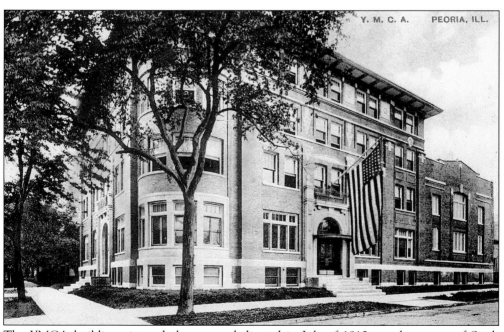

The YMCA building pictured above was dedicated in July of 1912, on the corner of Sixth Avenue and Franklin Street. This building was constructed by Fred Meintz of Peoria. This original building was sold and became a hotel. It was finally demolished in the early 1960s.

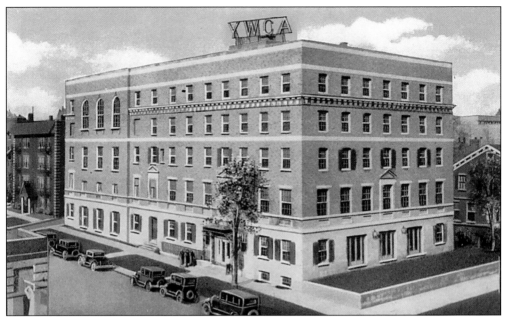

The YWCA was organized in November of 1893. After several different locations, the above five-story brick and stone building, which cost $305,901, was opened in September 1929. The lots on which the structure is located, at Fayette Street and Jefferson, were a gift from the Morron family. This organization still functions from the same location.

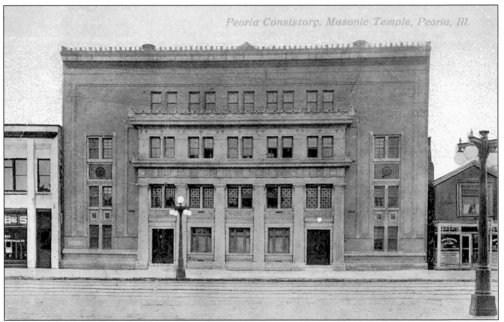

The Masonic Lodge purchased the Bradley Memorial Church, located at 727 Main Street, in 1899. The lodge removed the two front steeples and added the new facade, as pictured above. The gable roof remained, but the auditorium was remodeled into a temple, and the building was destroyed in 1972.

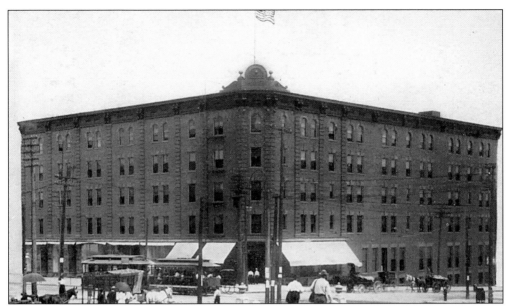

The Hotel Mayer was built in 1905 at Adams and Hamilton, the site of the former Peoria House Hotel, which had been destroyed by fire in 1896. The successful Hotel Mayer had 158 rooms and was operated by the family of David Mayer, until the complex was converted into apartments. The building was destroyed by fire in 1963, with some lives lost. Security Savings was constructed on this site. Today, Caterpillar uses the building as an office annex.

"Lover's Leap," near Jubilee College, was photographed by J.F. Kegebein in the 1920s. Although the state of Illinois is the Prairie State, the Peoria area is quite hilly.

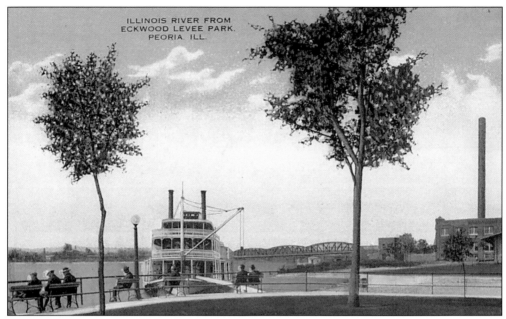

Steamboats had a landing at Eckwood Levee Park in the 1920s. The trees were still very young in this picture. The name Eckwood was derived from the names S.W. Eckley and E.B. Woodruff, who were both prominent city officials. The steam plant smokestack is visible to the far right.

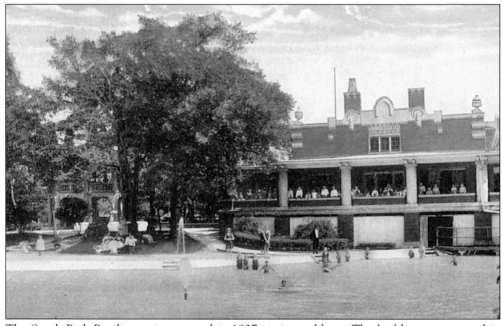

The South Park Pavilion as it appeared in 1927 is pictured here. The building was opened in 1913 along with a wading pool. South Park became Trewyn Park in 1937 to honor south side physician William Thomas Trewyn. Dr. Trewyn practiced medicine from 1906 until his death in 1926. The pavilion remains today, but the wading pool has since been removed.

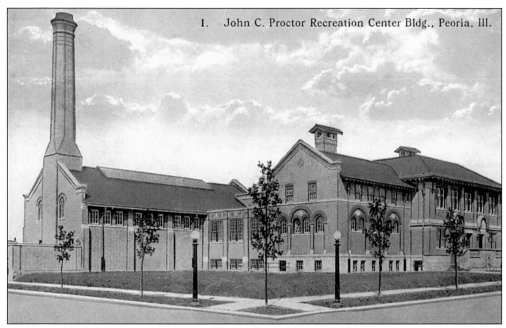

1. John C. Proctor Recreation Center Bldg., Peoria, Ill.

Banker and lumber giant John C. Proctor left funds to provide a center in Peoria's south side for free baths and other facilities. Constructed in 1913, this building is located at 309 South De Sable Street. This center still remains today, and has been managed by the Peoria Park Board since 1934.

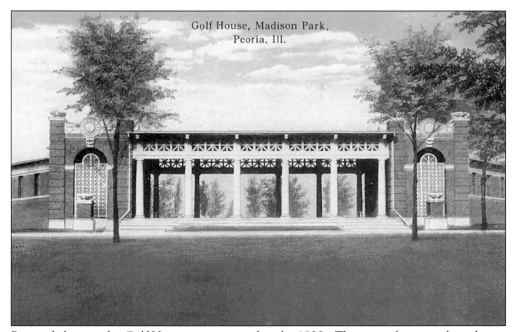

Golf House, Madison Park, Peoria, Ill.

Pictured above is the Golf House as it appeared in the 1920s. The spaces between the columns were later filled in to provide additional use for this building constructed in 1915. The large green area in the front was eventually paved to accommodate automobiles.

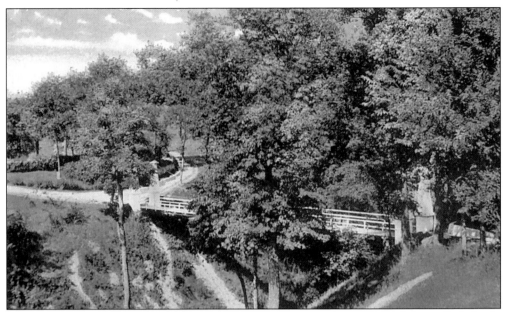

The photographer emphasized the suspension bridge, the gully, at the Madison Park Links in this 1925 postcard. The bridge connected several walkways and paths, but wood created a constant maintenance problem, and the bridge was later removed.

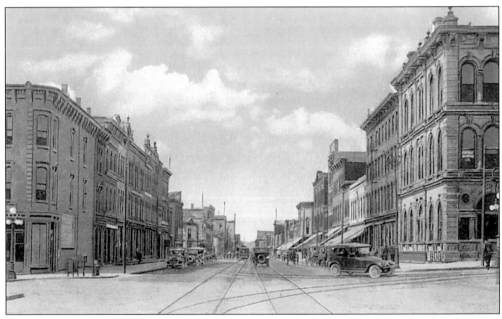

Southwest Washington is shown here as it appeared in 1921. Automobiles had replaced wagons and horse-drawn buggies for the most part. The German National Bank, which was built in the early 1880s, is shown in the right corner. All buildings in the postcard were demolished by the 1960s. The block to the left became Washington Square, which is Mass Mutual Insurance Agency today.

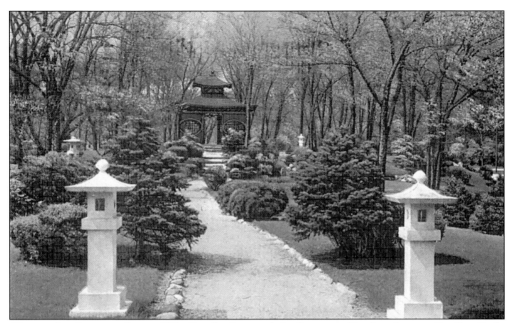

Chicago landscape architect T.R. Otsuka designed the Japanese Gardens here in Bradley Park. The walkway lead to this the highest ground point in the garden at the time, which was the teahouse, appearing in the middle of the photo. This card was mailed in 1938, and the gardens were subsequently removed following the Japanese attack on Pearl Harbor. The teahouse has since been reproduced and placed in the same spot.

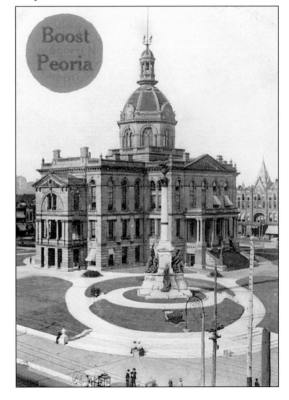

This "Boost Peoria" slogan was superimposed on a series of postcards by C.V. Williams of Bloomington, Illinois. Williams produced postcards throughout the Midwest. This logo superimposed upon was for the Modern Woodsmen of America, and is an early example of postcard recycling. The building is the Peoria City Courthouse constructed in 1874 and removed in 1963.

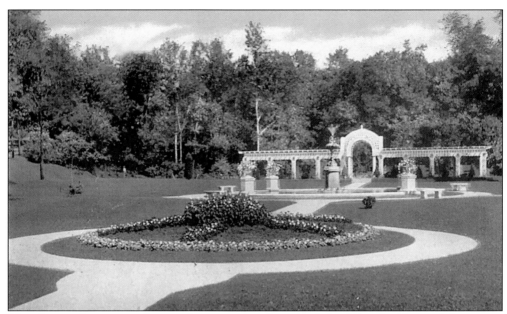

The electric fountain and rose arbor once stood to the left of the double road, known as the Perry Avenue entrance, leading into Glen Oak Park. The wood pergola, or arbor, was constructed in 1919, and this entire area was also known as the lower sunken garden. As with many wooden structures, this rose arbor was destroyed in 1951.

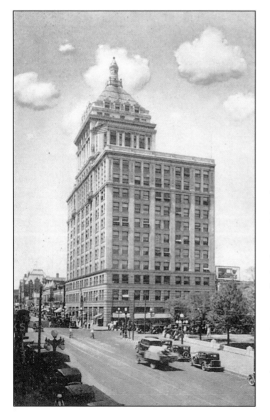

The Peoria Life Insurance Company began construction on Peoria's most striking building in 1918, with completion in 1920. Emmett C. May was the head of this company, and the driving force behind the development of this 17-story edifice. This card was one of the last symbols of this great insurance company. During the Depression, the company plunged into receivership, and was later obtained by the Alliance Life Insurance Company of Des Moines, Iowa. In 1946, the First National Bank of Peoria purchased the building for $935,000, and after remodeling, the bank occupied part of this building beginning in 1949.

The entrance to Laura Bradley Park was remodeled in 1954, as pictured above. A statue of Hebe, goddess of youth, was removed after an auto accident, and this entrance was reworked to eliminate the auto access to the park from Main Street.

The photographer did not realize that he captured a view of the Max Newman Fountain in Bradley Park in this photo. The Newman home once stood at 607 Main Street. The house was demolished in 1918, and the fountain was donated to the Peoria Park District and placed here in Bradley Park. The metal fountain was removed around 1950.

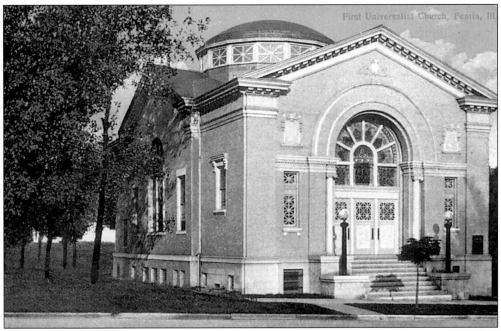

The Universalist Church constructed the above building in 1911 on Hamilton Street. They had just sold their previous building at 727 Main Street to the Masonic Lodge. In 1912, the church voted to change its name to First Universalist Church, as this card denotes. In 1964, the name was again changed to Universalist Unitarian Church, and stands today in excellent condition.

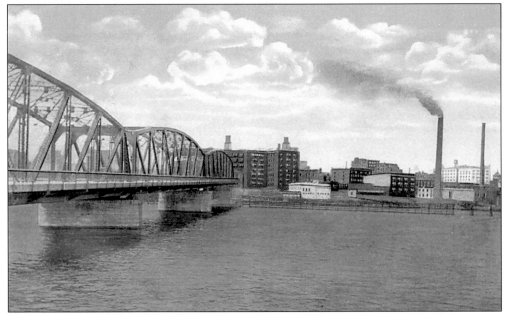

The Lower Free Bridge is pictured in this card postmarked in 1920. However, this bridge, with its famous kink, became known as the Franklin Street Bridge. The bridge was finally removed in the 1990s and replaced with a modern span, which was renamed the Bob Michael Bridge, honoring Peoria's long-time congressman.

Four

1941–1960
WAR YEARS AND PROSPERITY

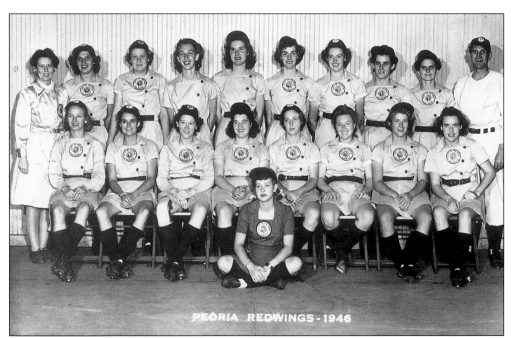

The Peoria Redwings became affiliated with the American Girls Baseball League from its inception in 1942. The league was formed by P.K. Wrigley, owner of the Chicago Cubs at that time. All of the team members above were paid, but each player also had other employment as well. This team existed until 1954, then faded out along with the league.

The Timberline Hotel was opened around 1950. This small building is still located at the corner of Route 116 and Anna Street. Several motels were constructed in this area to accommodate the auto traffic entering and leaving Peoria using this same route. In 1972, this motel was sold to an ambulance company that used the facility for their headquarters and storage of vehicles. This building functions today as apartments.

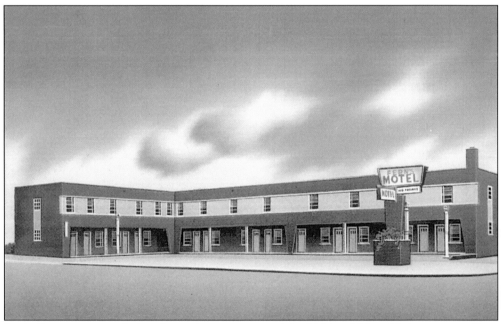

Louis Fern constructed the above downtown motel in 1954, which added a metropolitan touch to the downtown scene at South Monroe and Fulton Streets. The site had formerly been the Harry Tynell Motor Company. The L-shape brick structure was built for $125,000, and was unlike the other motels built in the 1950s. Unfortunately, it burned in 1972 and was never rebuilt.

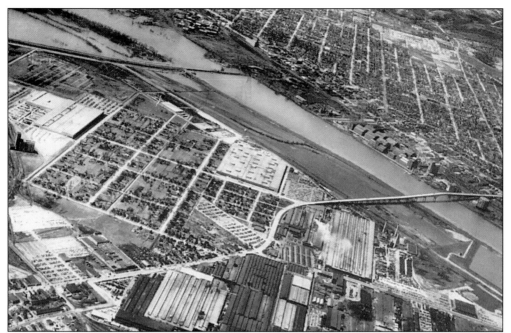

This is the aerial view of the Peoria Riverfront, at Hiram Walker's and the Caterpillar Tractor Company. It was reported that there were approximately 5.5 million square feet under the roof of the Caterpillar East Peoria Plants. Note how the bridge approach has changed—today, the highway continues straight, thus eliminating the curve.

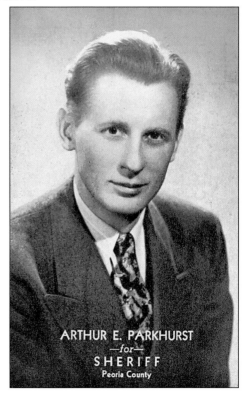

Personal Plea was the approach taken by Arthur E. Parkhurst when he mailed this card on April 4, 1950. He was running for sheriff on the Democratic ticket. The primary election was held on April 11, 1950, and William J. Littell defeated Parkhurst.

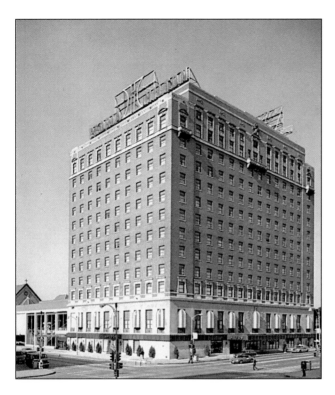

The Peoria Hilton was the name chosen when the Hilton chain acquired the Pere Marquette in 1972. Placing both names at the top of the building would have cost an additional $30,000. The hotel retained the name until 1993, at which time it underwent major renovation and reopened as the Pere Marquette.

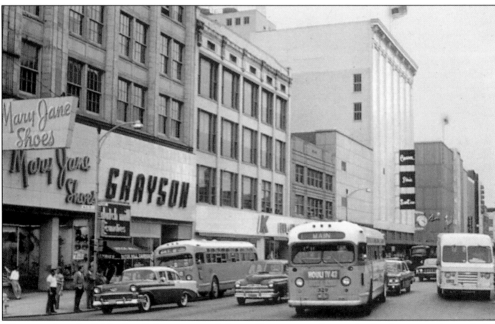

The one hundred block of downtown Adams Street was the main business section of the city in the 1950s. Adams Street was a wide thoroughfare and Peoria's longest business street. At the release of this particular card, Peoria was the third largest city in Illinois. Note the KMart in the center of downtown. All buildings, except for the Carson Pirie Scott building, have been demolished.

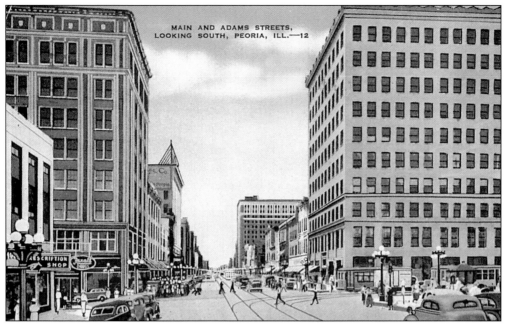

The Clark Department Store (left) was 12 years old when this card was mailed in 1940. The Central National Bank is dominant to the right. In 1914, the building had added another wing. By the time this card was mailed, this addition had faded to the point of not being recognizable.

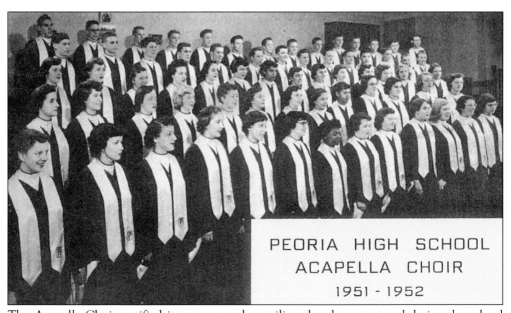

The Acapella Choir notified its supporters by mailing the above postcard during the school year of 1951–1952. These cards were mailed to locations as far as Pontiac, Illinois. The choir continued to function well into the 1970s.

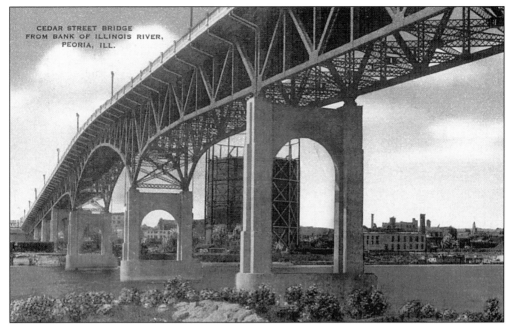

The Cedar Street Bridge was a result of the expanding activity on the east side of the Illinois River by 1928. The structure was designed by the Strauss Engineering Company, and built by Congress Construction Company and Kelly Atkinson Companies—all from Chicago. The bridge opened for service with a ceremony on January 6, 1933. The delay was a result of difficulties in acquiring the land necessary for the east approach.

The YMCA came to Peoria in December of 1852, when interested men met in Frank Hall and began this movement that is still strong in Peoria today. After several different locations, the present site at 714 Hamilton Boulevard was selected. The building fund drive began in 1943, and reached an amount of nearly $1.5 million by the early 1950s.

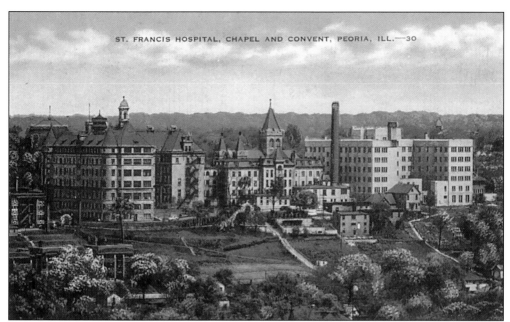

The Sisters of the Third Order of St. Francis founded the St. Francis Hospital in 1878. St. Francis is one of the finest and most completely equipped hospitals in the country. Note the stunning view of the hospital chapel and convent displayed in this postcard. Also note that the center building in the top card was the Isaac Underhill Mansion, built in 1841. This building represented the beginning of the hospital complex. The card below shows a view in 1935 with the building removed.

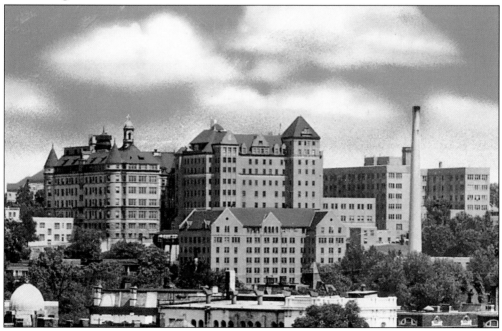

The children's section of St. Francis Hospital was dedicated in 1954, and was made possible by contributions from local industrial corporations and citizens of the Greater Peoria area. The upper two floors accommodate up to 96 children, and the first floor serves as a clinic.

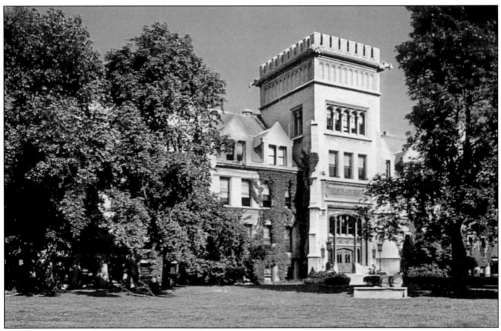

Bradley Hall, in the center of the Bradley University campus, was constructed in April of 1897. Bradley Hall remained much the same, as this postcard mailed in 1960 indicates. A fire in 1963 changed the roof line forever, and President Richard Nixon made a contribution to the reconstruction of Bradley Hall after the fire.

A night view of Bradley Hall is pictured to the right. Lydia Moss Bradley regularly sought the advice of Dr. William R. Harper of the University of Chicago regarding the establishment Bradley University. The first classes were conducted October 4, 1897, although Bradley Hall was not yet complete.

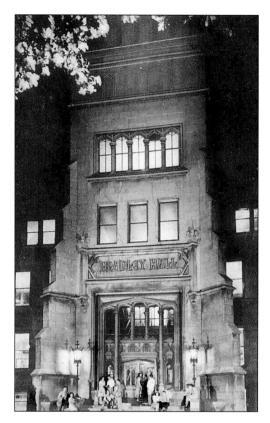

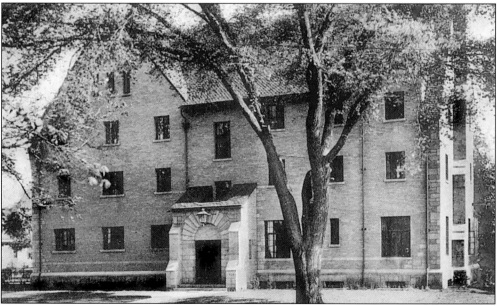

Jennie M. Constance headed the Bradley English Department for nine years until her death in 1928. To honor her, Bradley University constructed the building pictured above, Constance Hall, between 1930 and 1931. This building was used as a dormitory for women until it became the Music Department in 1962.

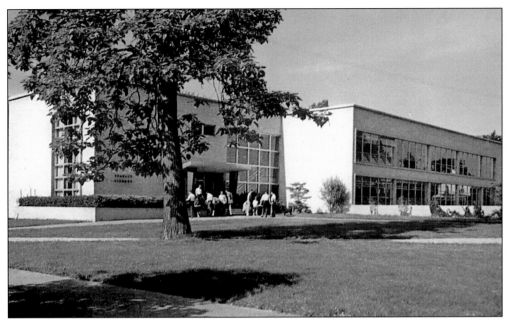

The Bradley University Library, pictured here in 1955, began in a one-room basement at Bradley Hall and expanded into this modern building. Groundbreaking occurred in October of 1948, and the building was finally completed in 1950. A second expansion occurred in 1966, due to a $1 million gift to the university. Shelly Cullom Davis, a Peoria native, presented the money in honor of his parents, Julia M. Cullom and George H. Davis. The university renamed the library the Cullom-Davis Library that same year.

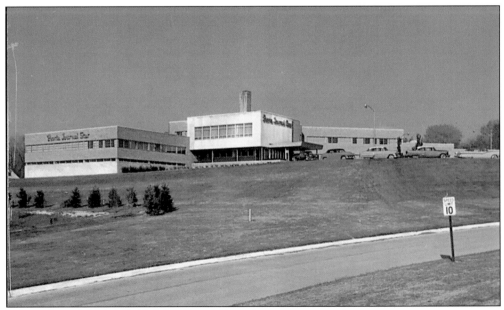

The *Journal Star* moved to the building pictured above in 1955. Just one year prior, the *Journal Transcript* and the *Peoria Star* merged, forming the current newspaper. This Memorial Drive location was a $1 million plant, and one of the world's most beautiful newspaper plants.

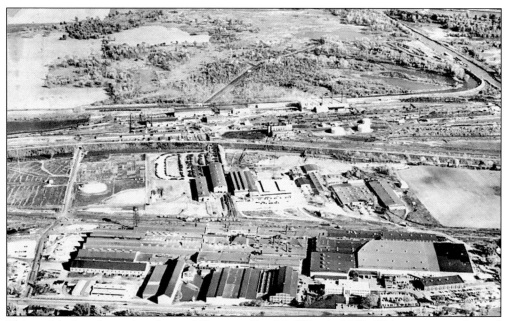

This aerial view shows the plants of Keystone Steel & Wire in 1958. This company is located on a site comprised of nearly 913 acres just south of Peoria, at Bartonville. The general office is the white building in the lower right center of this postcard. The Illinois River is in the background at the top right of the picture.

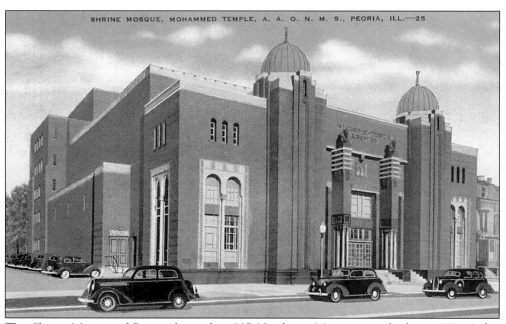

The Shrine Mosque of Peoria, located at 207 Northeast Monroe, was built in 1909. A fire occurred in 1936 that destroyed the entire original structure except the twin towers and domes. The Mosque, pictured above, reopened in 1938 and still serves the community today.

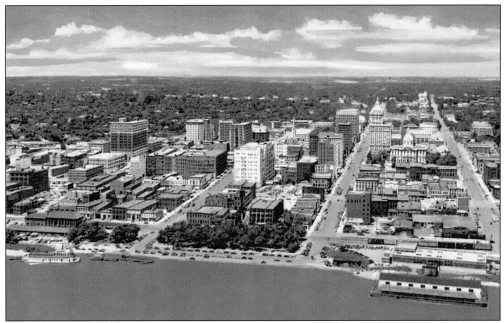

This is a 1955 aerial view of downtown Peoria. The Sears Block would be completed in 1965 (center middle), and Eckwood Park lost most of its trees. The World Headquarters of the Caterpillar Company and its parking deck did not appear until the middle 1960s, and the Tech Center filled the block cross from Bank One, the center white building.

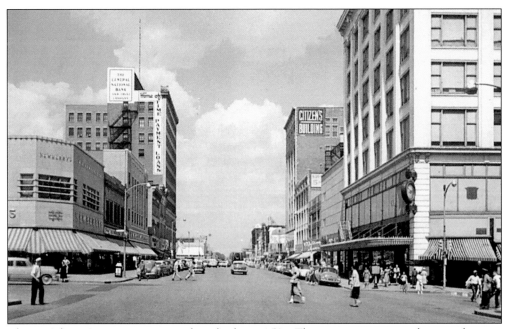

This is Adams Street as it appeared in the late 1950s. This street encountered many changes. The Kuhl & Block building (far right) later became Bank One, the Citizens Office Building (middle right) was razed in 1980 to become a parking lot for Caterpillar, and the Central National Bank (left) merged with Commercial National Bank in 1961.

Five

PRESENT
VIEWS OF A RIVER TOWN

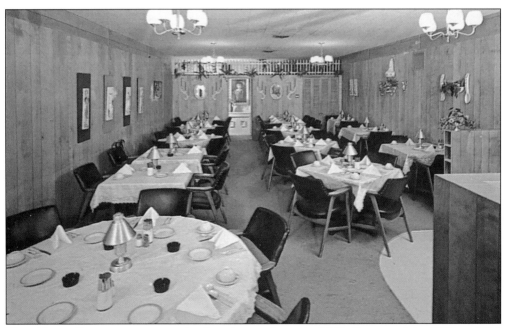

The Alcove Restaurant appears in the picture above in 1966. It opened in 1965 at 2411 Knoxville, next door to Andy's Drive Inn—a car hop business. By 1975, the location became known as Kings Row, and then Mar-Don Corporation Night Club in 1978. Stormy Alcove was there back in 1979, and another name change occurred in 1981, to G.E.B. Place. G.E.B. Alcove reopened in 1987, but was short lived. In 1988 the building was vacant, and burned. Today the location is the C & L Vacuum Cleaner Shop.

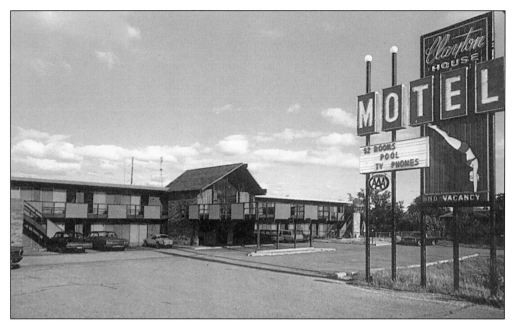

The Clayton House Motel was brand new when this postcard was mailed in 1965. The 52-unit motel was originally opened by William Downs Jr. in 1961 as the Skylark Motel. Downs also owned the restaurant next door, which was known as the original O'Murphy's Restaurant. The motel and restaurant facilities next door offered a package arrangement. By 1963, the name was changed to the Clayton House, and it retained this name until it became the Delux in 1998.

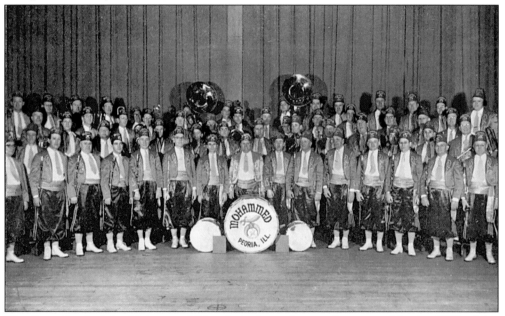

The Brass Band of the Mohammed Temple is shown here as it appeared in the 1970s. John Glasgow formed the first band with 16 members in 1918. Forrest J. Woodman was the director when the members assembled for this postcard picture. Members from within a hundred mile radius traveled to attend rehearsals and take part in ceremonies and activities of the Shrine Mosque located at 207 North Monroe Street.

The corner of Jumer's Castle Lodge Dining Room is pictured as it appeared in 1975, when this postcard was mailed. Jim Jumer purchased the restaurant in 1960, and later expanded the eatery and built a motel that bears his name. The corner is the same today as it was when this postcard was mailed.

Jumer's Castle Lodge

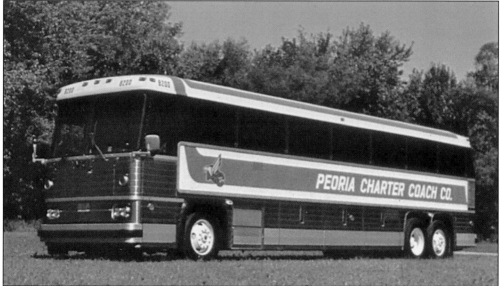

The Peoria Charter Motor Coach #241 is a symbol that carries the name Peoria to 23 states. The familiar red, along with "Caterpillar yellow," symbolized the name Peoria. The coach began in 1941 to assist in transporting men to the Caterpillar plant from adjoining areas. The company proudly proclaims steady growth today as it continues to transport customers on various customized tours.

GARY
SANDBERG
City Council

You're Invited
because you have been
so helpful in the past. I
hope I can count on your
support this election.

WHERE: 2807 NORTH LINN STREET
WHEN: SUNDAY, JANUARY 26 at 12:30 until 2:00

CAMPAIGN KICKOFF and ORGANIZATIONAL MEETING

CALL RUTH IF YOU ARE UNABLE TO ATTEND (PHONE 673-1430 or
682-2564 MAILBOX 4), BUT ARE INTERESTED IN HELPING MY REELECTION
EFFORT.

NEIGHBORHOOD AND PRECINCT INFORMATION WILL BE DISTRIBUTED
BRING SIGN LOCATIONS OR NAMES OF INTERESTED SUPPORTERS TO
MEETING. LIGHT FINGER FOOD AND REFRESHMENTS PROVIDED AND
MEETING WILL BE OVER BEFORE SUPER BOWL. I HOPE YOU CAN MAKE
IT. GARY and JELLY BEAN

This postcard is a fine example of how hopeful candidates organized and promoted their candidacy. Original notices such as these became a direct mail contact used by candidates in the 1990s. The card must have worked, because Gary Sandberg has never been defeated!

Markley *for* 2nd District

Don't forget to vote on February 28!

COUNCIL

Don Markley's bid for the Peoria City Council race in 1989 was an example of a turn from the traditional picture postcard commonly used in the 1950s. The use of graphics rather than a photo or drawing to produce an object such as a lamp post was a new trend. The political message was evident by the use of two-part color. Sandberg defeated Markley in the first political race for both of them.

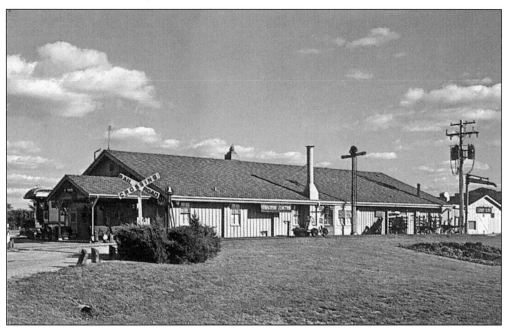

Vonachen's Junction announced its opening at the intersection of Knoxville and Prospect Streets on May 1, 1956. Keller Station had provided service at this location from 1884 until 1927 as the first stop on the Rock Island Railroad; however, information timetables indicated a stop at this location as late as 1941. Pete Vonachen established Vonachen's Junction restaurant with a railroad motif, and added the private car of the late George P. McNear in 1957 as an additional dining area. This establishment still operates at this location.

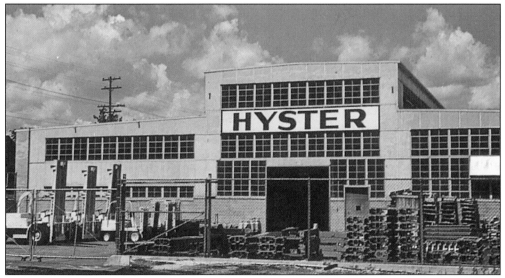

Willamette-Hyster opened a branch in 1936 at 1800 Northeast Adams. The former occupant of this location had been Peoria Stone and Marble Works. This company had manufactured winches and cranes for mounting on tractors, exclusively for the Caterpillar Tractor Company. The plant was expanded and remodeled twice over the years. During WW II, Hyster's forklift trucks and heavy winches were pressed into war service. By the middle 1970s, the Peoria plant was the second oldest only to the home office in Portland, Oregon. The plant closed by 1976.

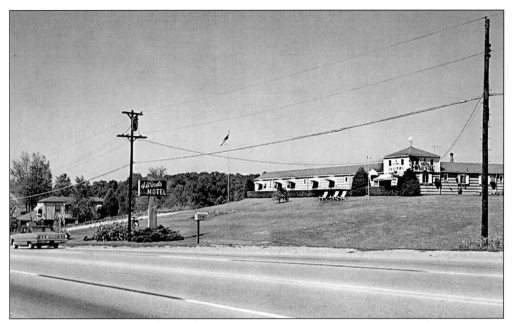

The Four Winds was one of several motels constructed on Harmon Highway (Route 116) to attract travelers as they entered Peoria. The motel was conveniently close to the airport at Bartonville, and was a mere ten minutes from downtown Peoria. A spacious lawn displayed in this card provided a buffer against the highway noise. Tom Kallister maintained this large grassy area in the early 1950s. The motel was destroyed in 1974, and later became the site of a large chain grocery store.

The Americana Nursing Center was a $270,000 facility; construction began at 5600 Glen Elm Drive in 1962, and the center opened January 6, 1963. Operated by Americana Nursing Incorporated, the Williamsburg-style building provided short and long-term rehabilitation care for patients who did not need the more intensive services of a general hospital. The cupola was eventually removed, and the facility is presently known as Manor Care Health Services.

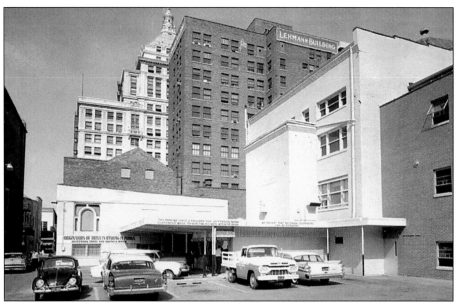

This postcard commemorates the opening of Peoria's first drive-in banking services at Jefferson Bank. The building to the left of the Lehman Building was the auditorium of the Empress Theater, which faced Main Street. The drive-in bank was located in the rear of 113 Southwest Jefferson. The bank razed this facility in 1963. By 1978, Jefferson Bank relocated to the Carson Pirie Scott building at 124 Southwest Adams. Jefferson Bank became part of Bank One by 1992.

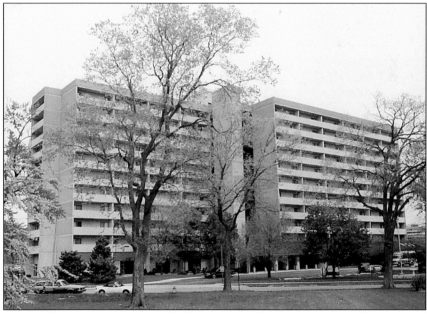

The B'Nai B'rith Organization constructed the apartment complex shown above in South Town through the leadership of Sam Stone in 1979. This impressive building is located at 215 West Sixth Avenue, and a later addition brought the entire block under the direction of B'Nai B'rith. In 1999, Sixth Avenue was renamed Sam Stone Avenue to honor this great man whose vision made this project a reality.

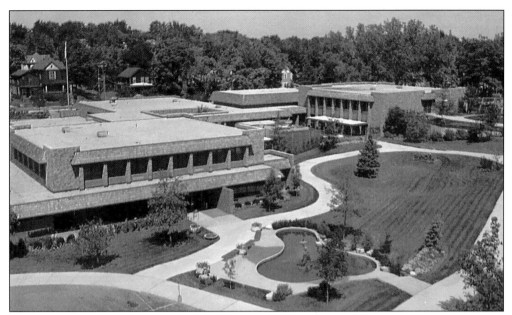

The Allied Agencies Center consolidated into one complex at 320 East Armstrong Avenue. This complex, which was built in the late 1970s, housed the Arthritis Foundation, Board of the Care and Treatment of Mentally Deficient Persons, Council on Alcoholism, Community Workshop, Crippled Children's Center, Cystic Fibrosis Chapter, Mental Health Association, Mental Health Clinic, Peoria Association for Retarded Children, United Cerebral Palsy, Vocational Evaluation and Training Section, and IPMR. Many changes have taken place within each of these organizations.

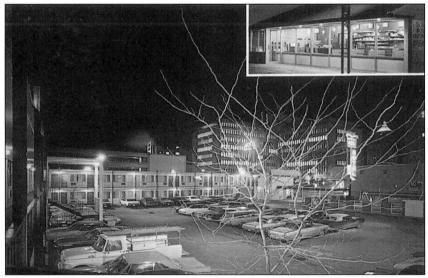

The Peoria Imperial 400 Motel was photographed with the Caterpillar World Headquarters in the background. The Imperial was located at 202 Northeast Washington Street. The "royal" (later name) accommodations offered a heated swimming pool, free television, room telephones, air conditioning, free coffee, 63 total units (some with kitchens), conference rooms, free advance reservation service, and a 24-hour coffee shop. Today the motel operates under the name of Budget Motel.

The Junction City Shopping Center opened in 1959 at Knoxville and Prospect Streets. The "Old West" styling of the one-story building was built in three phases. The center of this postcard is the Edward Easton Fountain, which was commissioned to Tribel and Sons by Mrs. Easton in 1901 to build a total of eight drinking fountains. The one at Adams and Evans (pictured above) was relocated in 1967 to the Junction City site, where it remains today.

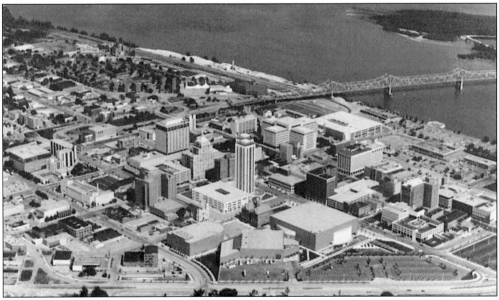

The downtown aerial view also served as a large calendar, and was produced in 1982 by photographer James P. Carr—also known as "Skyflick." The twin towers were the most striking buildings, and they appeared here as completed; however, they were still under construction, so Mr. Carr had the buildings painted in to show how beautiful the skyline would look upon their completion in 1984.

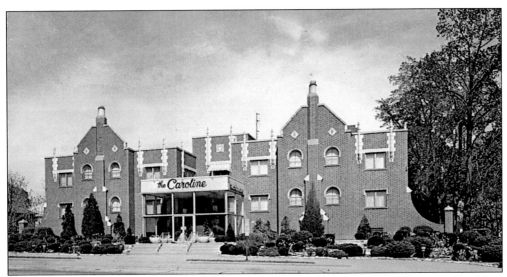

Manias Apartments, located at 1506 North Knoxville, opened in 1931, and a second building was completed in 1939. This brick and stone apartment complex overlooks the city of Peoria and the medical center. However, many name changes have occurred over the years. In 1956, the complex was converted to Manias Motor Lodge in order to accommodate shorter visits. The solaria, a garden-type lounge, was added that same year. On the roof of this building was a garden overlooking the city. The name changed again in 1971 to the Caroline when ownership changed hands. By 1990, yet another new owner, Merle Huff, purchased the building and it was converted to upscale apartments.

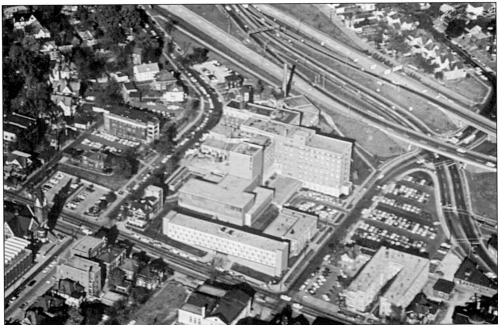

The Methodist Hospital Complex is pictured here as it appeared in the 1960s. The hospital opened its doors in 1900 as Deaconess Home Hospital Association. In 1917, the name changed to Methodist Hospital, and the current name, Methodist Medical Center, was adopted in 1975. This modern 550-bed hospital offers complete hospital services to patients.

Vonachen's Hyatt Lodge, pictured above, was originally opened in 1966. The motel offered guests an indoor pool, coffee shop, and cocktail lounge. The lodge was constructed using bricks from buildings that had been razed in connection with Peoria's downtown expansion. Some bricks were more than one hundred years old and were highly sought-after for their appearance and durability. The name of the lodge changed to Junction City Lodge and still operates today, but under the present name—The Grandview Hotel.

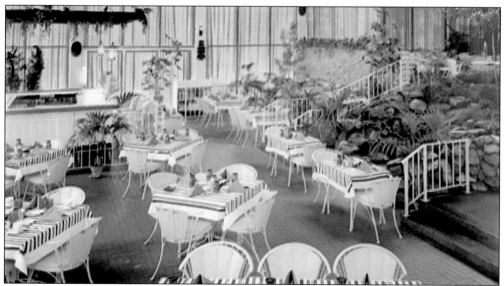

The Ramada Inn Hotel opened with great fanfare at St. Mark Court in 1970. The downtown location was built in order to accommodate travelers from the nearby Interstate 74, as well as local hospitals. The building is no longer used as a motel, but became a part of the Methodist Medical Center of Illinois, and is referred to as "Methodist East Campus."

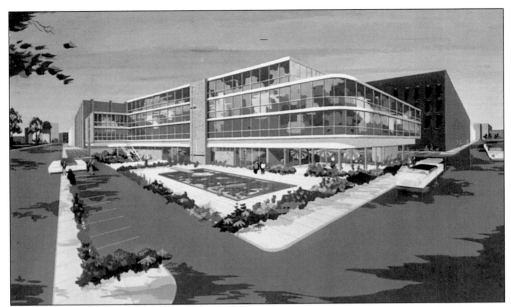

The Sands Motel opened in August of 1960 as part of the Peoria downtown redevelopment. The modern glass and aluminum building was located at 220 Northeast Adams. Over the years, this 105-room motel went through a series of new owners and new names, until it closed in 1983. With all hope for renovation lost, Frietch & Company finally demolished the building in August 1985.

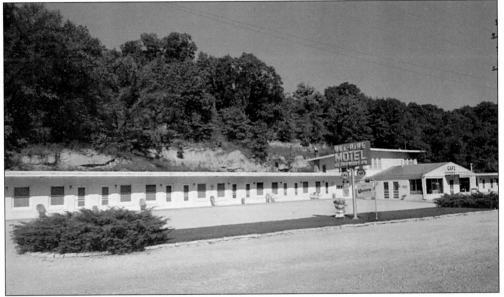

The Bel-Aire Motel was built by S.R. Gasparovich in 1950 to accommodate both the airport industry and automobile traffic from Route 116 or Harman Highway. The 14-unit motel was located just ten minutes from downtown Peoria and offered many amenities, including an adjoining cafe. The cafe burned in the mid-1960s and was replaced by the Search Light Lounge Chalet. The floors of this new restaurant were salvaged from the recently destroyed Peoria Court House; however, the motel was closed. A later owner removed the restaurant and a large part of the rooms to the west, and the building remains only partially used today.

Bishop Buffet moved several times through the years before acquiring this location. The Washington Square location opened in 1965 at the intersection of Washington and Main. Massachusetts Mutual took over this building in the mid-1990s, and Bishop's is no longer in Peoria today.

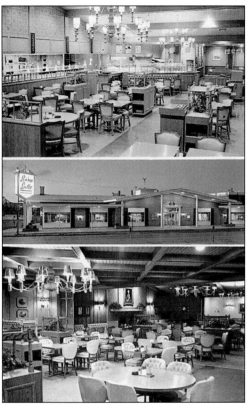

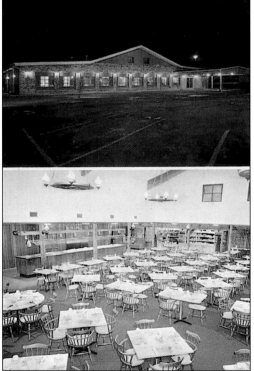

The Heritage House Smorgasbord opened at the location shown above in the late 1960s in the expanding area of North Peoria. This restaurant, located at 8209 North Knoxville, continued until it was torn down and replaced by the Eagle Supermarket in the mid-1980s.

WHEELS O' TIME
Peoria, Illinois

The Wheels O' Time Museum was a collaboration of classic car buffs to create a private museum. There are three large buildings located at 11923 North Knoxville, which house displays of antique vehicles, clocks, music machines, trains, farm equipment, fire engines, tractors, and much more. The museum opened in 1983.

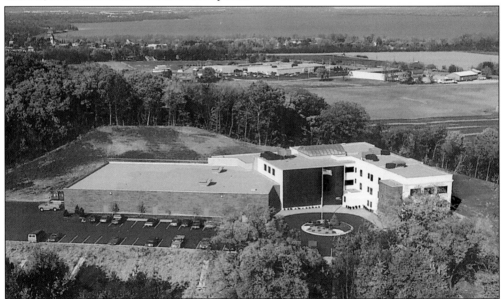

Dynamic Graphics' World Headquarters is pictured above as it appears today on Galena Road, where it is surrounded by an 800-acre nature park. Employees of this company enjoy a panoramic view of the Illinois River and Lake Peoria. The main building (far right), which housed the Municipal Tuberculosis Sanitarium, was constructed and opened to patients on April 11, 1919. The hospital later closed and this building was rehabilitated and expanded to its current size by 1982.

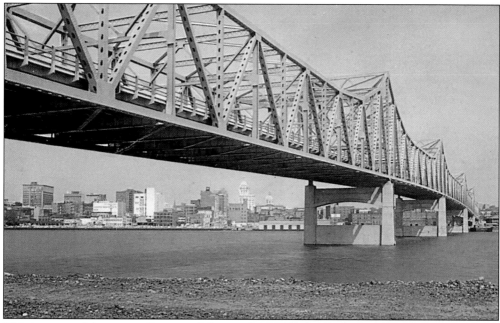

This is a view of downtown Peoria and the new Murray Baker Bridge spanning the Illinois River in 1961. This bridge was opened along with the adjoining expressway system in 1958, and cost $16 million. The bridge was a link in the interstate system that was routed through the heart of Peoria. Lighting was added outlining this bridge on July 4, 1991.

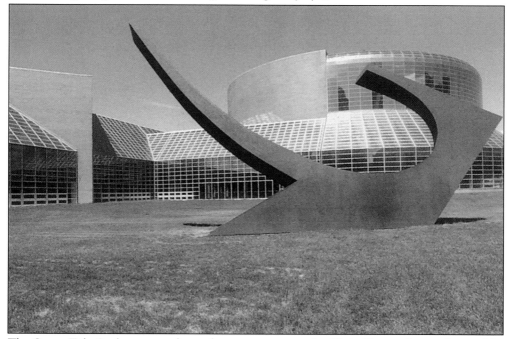

The Sonar Tide Sculpture stands on the green space at the Civic Center. It was designed by Ronald Bladen and is known to some as "The Plow." Van Buskirk Construction produced the 16-ton sculpture in Peoria. The donors by this gift contributed support for the redevelopment of the downtown.

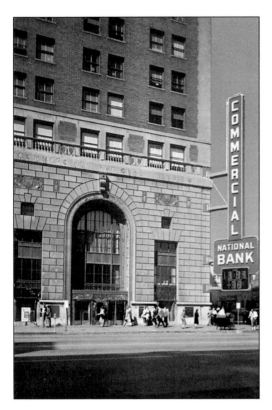

The corner of Liberty and Southwest Adams remained the same beginning in 1926 with the completion of the Commercial National Bank, with the exception of a few name changes. This bank acquired other banks through consolidation, failure, or liquidation over the years. This famous sign displayed temperature and date for many years. In the 1980s, this institution became part of Midwest Financial Group, then First of America took over. By 1998, National City Bank placed their name on this building due to another merger.

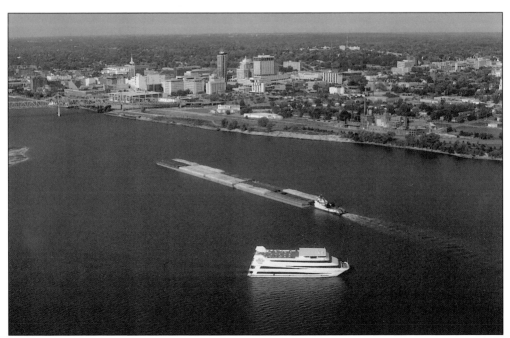

"Skyflick" captured this perfect aerial picture of Peoria in 1994. The new *Pair A Dice Riverboat Casino* is shown cruising the Illinois River with the Peoria skyline in the background.

Six

INVITATIONS AND MESSAGES FROM PEORIA
FUN CARDS

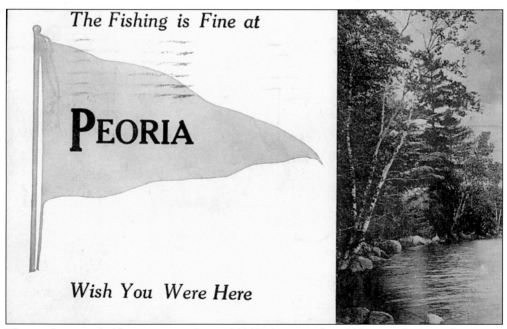

This card was mailed by a visitor in June of 1912. A postcard could be sent for 1¢ at this time.

The sender of this card lived at 418 Vine Street in Peoria, and he was writing home to inform family and friends that he was going to work at Avery that morning. The message indicated that there was lots of work available and that Peoria was some town. The card is postmarked October 10, 1917.

The sender of this card wanted to remind the receiver not to forget there was such a place as Peoria on the map.

Haf you seen de nice girls vat lif in PEORIA véll better you come qvick.

The writer of this card had just arrived in Peoria and was writing his sweetheart. He stated that he was leaving for Springfield at 10:00, and told her to "be good" and he would bring her something. This is a very early postcard, with postage still costing 1¢.

I ISS CHUST SENDING YOU DIS FROM PEORIA ILL UNDT BELIEFE ME IT ISS SOME TOWN.

The writer of this card was inviting her friend from Bloomington, Illinois, to come to Peoria while it was still warm and everyone was still outside. The card was mailed in July 1913, and required 2¢ to mail.

Well, here I am in **PEORIA, ILL.,**
Enjoying its sights and cheer.
Everything's great, and I'm feeling first rate
But O, how I wish you were here.

In the message space of this postcard is printed, "Don't let this surprise you, but let me gently remind you of the letters you've promised to write. If you have any time to drop me a line, here's hoping you'll do so tonight." The card was mailed in the early 1900s, as the 1¢ stamp indicates.

GREETINGS
FROM

Minnie Franzen

PEORIA
ILL.

202-2 COPYRIGHT 1907 BY ILLUS. POST CARD & NOVELTY CO., N.Y.

The sender of this card is writing her cousin. On the back of the card, she has printed a version of Roses are Red, Violets are Blue—"Roses are red, violets are blue, sugar is sweet and so are you, drink your tea in remembrance of me, drink it hot, forget me not!"

This card was written on a Monday evening in 1913 at around 9:30, p.m. The writer states that he had just gotten home from a fine show at the Orpheum.

This card was sent to Miss Katie Johnson at 708 South Eleventh Street in Springfield, Illinois, with a brief greeting from James Johnson.

Raised in
Peoria, Ill.

The writer of this card seemed a little homesick. He writes that he hopes his friend is having a good time, and asks her to tell everybody hello. It is signed "Willie."

Never put off till to-morrow what you can do to-day

IN PEORIA

This card invites visitors not to delay whatever their business is in Peoria.

Seven

PARADES AND MILITARY CAMP LIFE

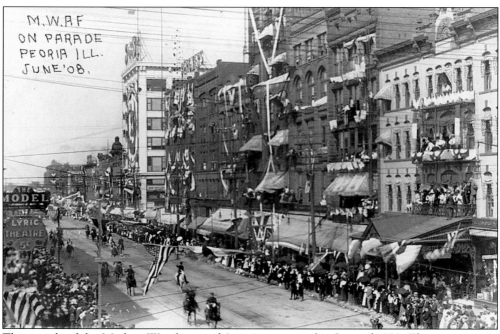

This parade of the Modern Woodsmen of America occurred in June of 1908. The procession is photographed in the two hundred block of Southwest Adams. Notice the spectators in the Fey Hotel standing on the balconies. The Modern Woodsmen of America was a mere 23 years old when this parade occurred.

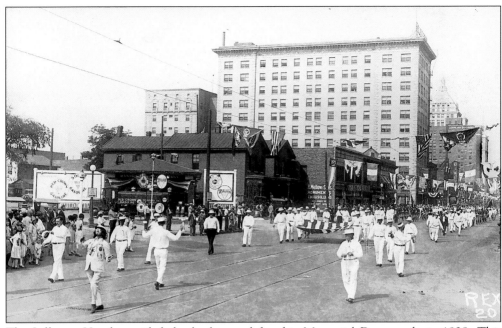

The Jefferson Hotel provided the background for this Memorial Day parade in 1928. This patriotic group carried a large American flag.

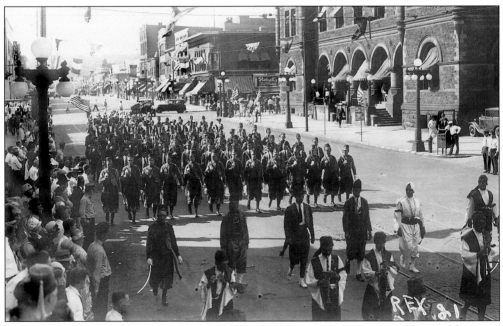

This parade journeyed past the old post office building (right) in 1928. This building was demolished in 1937 and replaced with the present structure at the intersection of Main and Monroe.

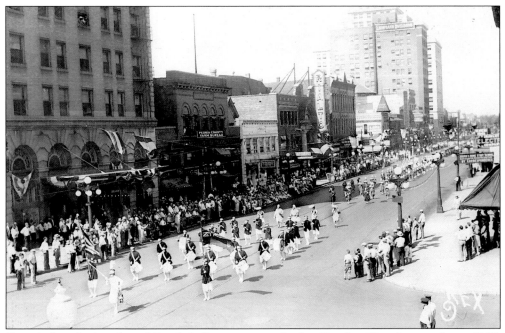

Crowds line both sides of South Jefferson to watch this Knights Templar parade in 1937. Recognizable to the far left is the Jefferson Hotel, which was built in 1912. The Peoria County Farm Bureau was located next door in the Kempshall Building, and the Rialto Theater is in the middle. At the far end is the Lehmann Building, which was constructed in 1916. These two blocks were demolished by the late 1970s.

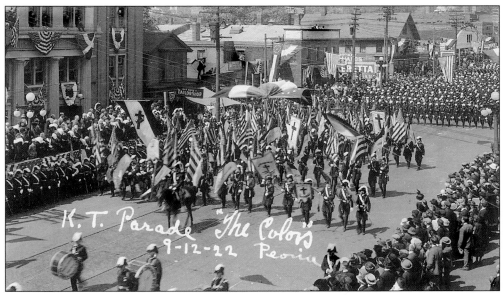

The Knights Templar's Color Guard had just reached the Masonic Temple here at 727 Main Street on September 12, 1922. The Knights of Columbus Spaulding Council Number 427 sponsored this parade. This council was named in 1902 to honor Archbishop J.L. Spaulding's silver anniversary in Peoria.

The Meet of June 1908 was held at the fairgrounds located on what is known today as War Memorial Drive. Marching in parades at these grounds was a vital part of the week's festivities.

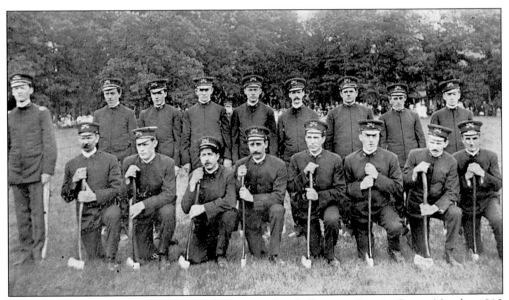

One of the many functions of the MWA was the drill team. Peoria Camp Number 812 displayed their talents here on June 20, 1908. This drill team had met at 622 Main Street twice each month prior to this date.

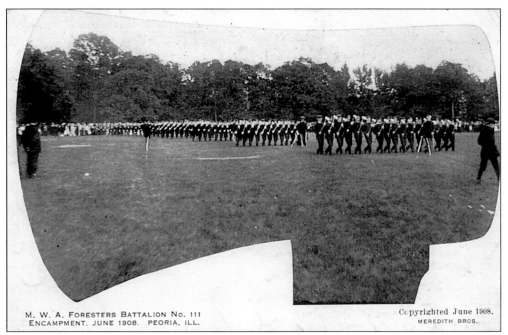

Forester's Battalion Number 111 Encampment began drilling at 4:00 a.m. This card was taken June 16, 1908, and shows the grand winners for that day.

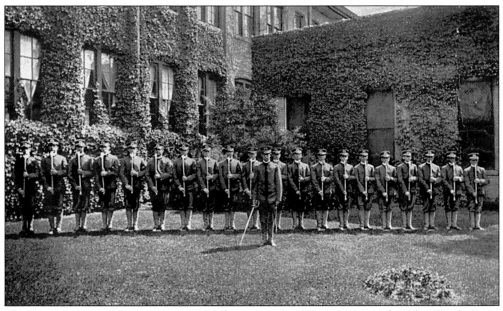

The visiting team to Peoria in June 1908, from Kenosha, Wisconsin, was the Pike Woods Camp Number 391. This drill team walked away with the national prize that year. Unfortunately, the members are not identified here.

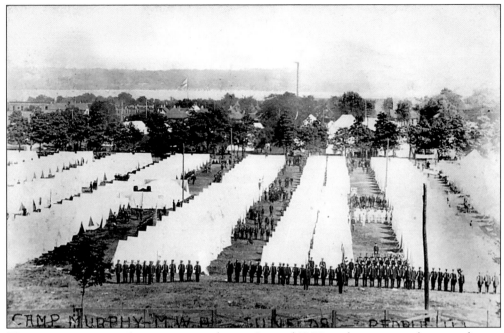

This panoramic view of tent city was taken in June of 1908, with many members standing at attention. The Illinois River can be seen in the background.

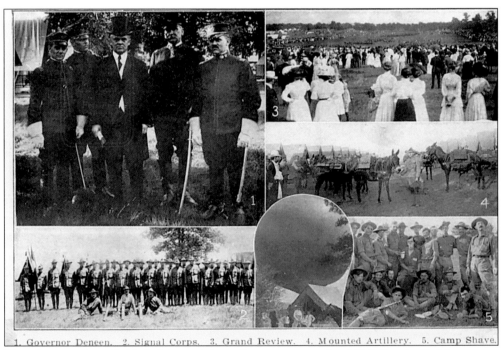

1. Governor Deneen. 2. Signal Corps. 3. Grand Review. 4. Mounted Artillery. 5. Camp Shave.

The photographer divided this card into five scenes at the 1910 Peoria Heights meet: (1) Governor Denee, for whom this camp was named; (2) Signal Corps; (3) Grand Review; (4) Mounted Artillery, and (5) Camp Shave. Several thousand soldiers were stationed at these areas.

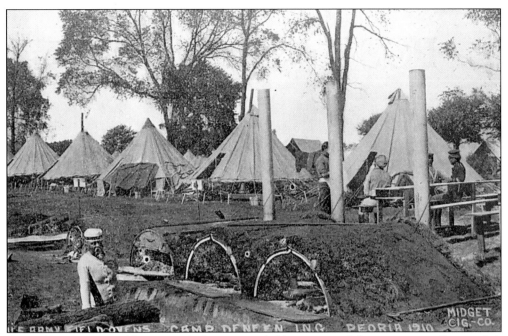

Camp Deneen was self-contained. Pup tents, field ovens, and latrines were all provided. The location shown above was located north of the railroad tracks, between Lake and War Memorial Drive.

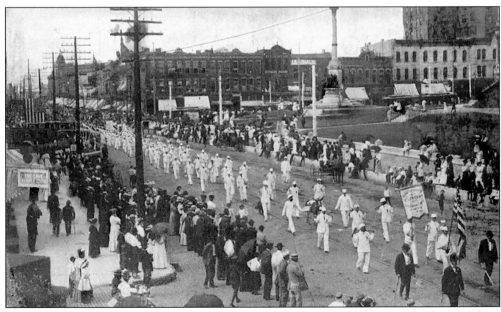

Shown here is a parade in 1912, as photographed from the Hotel Mayer at Northwest Adams and Hamilton. Central National Bank (middle left) was two years away from construction.

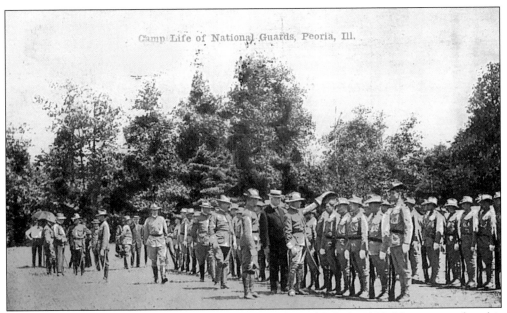

The Peoria unit of the Illinois National Guard was formed July 2, 1889. Nine years after this date, these same troops were called to action in the Spanish American War. Many of these men under review in June 1908 were also called to serve in WW I.

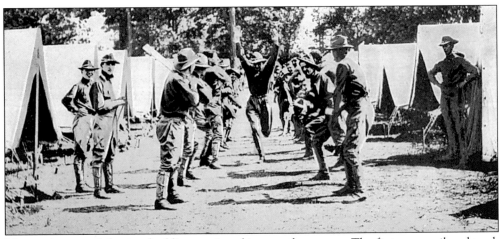

There were several thousand soldiers stationed in one of two areas. The first was a railroad track to Lake Street, from Monroe to Boulevard. The second location was War Memorial (known as Reservoir at that time) to London, from Prospect to Monroe.

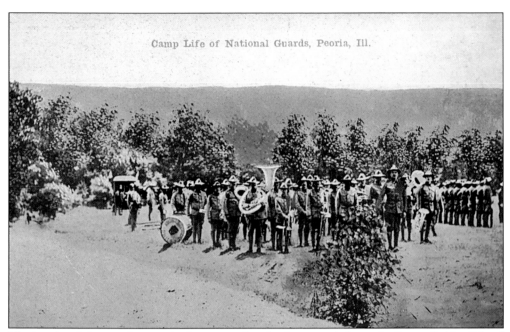

The band and the cavalry were both stationed at the fairgrounds (now the Peoria Public School Stadium). This location provided a grandstand to accommodate visitors.

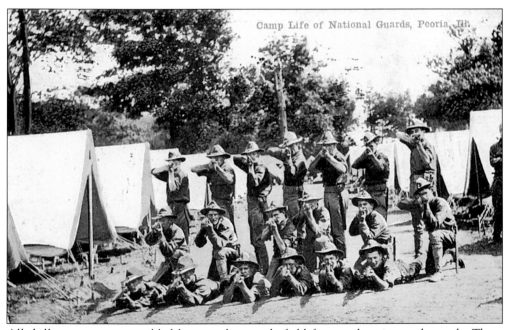

All drill teams were assembled here at the parade field for grand review and awards. These reviews were both on horseback and on foot. Unfortunately, the area could not accommodate the water needs and trucks used to provide these needs.

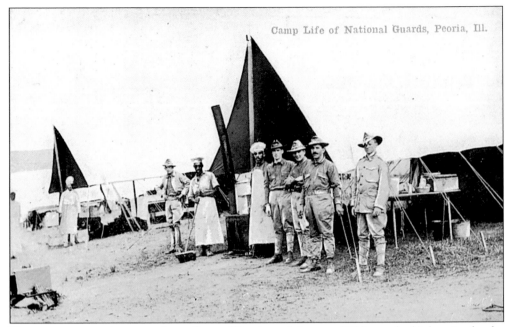

This encampment drew men form all over Illinois, and the year 1910 was the high point for the Peoria unit if the Illinois National Guard. Peoria was the center for the Guard for two weeks in the summer of this year.

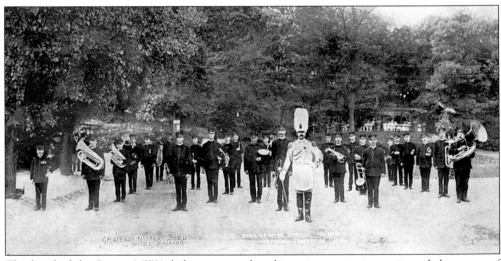

The band of the Peoria MWA led many parades, dispersing patriotic music and the name of Peoria, Illinois.